ꜱᴇᴜᴍ Theatre

Communicating with Visitors Through Drama

Catherine Hughes

Heinemann
Portsmouth, NH

Heinemann

361 Hanover Street
Portsmouth, NH 03801–3912
http://www.heinemann.com

Offices and agents throughout the world

Library of Congress Cataloging-in-Publication Data
 Museum theatre : communicating with visitors through drama / Catherine Hughes.
 p. cm.
 Includes bibliographical references.
 ISBN 0-325-00056-5
 1. Museums—United States. 2. Museums—Educational aspects—United States. 3. Drama in education—United States. 4. Museum techniques. I. Title.
 AM11.H84 1998
 069'.0973—dc 21 98-23690
 CIP

Editor: Lisa Barnett
Production: Vicki Kasabian
Cover design: Jenny Jensen Greenleaf
Author photo: Susan Byrne
Manufacturing: Louise Richardson

Printed in the United States of America on acid-free paper
T & C Digital

Toward a Definition:
Without seeking to limit what it can be,
Museum Theatre is the use of drama or theatrical techniques
within a museum setting or as part of a museum's offerings
with the goal of provoking an emotive and
cognitive response in visitors
concerning a museum's discipline and/or exhibitions.

Contents

Preface

This book grew out of my master's thesis at Lesley College in Cambridge, Massachusetts. I was enrolled in the Independent Study Master's Program, which for me included the study of museums, education, and theatre-in-education. To my great fortune, I enrolled in Joe Petner's class on Program Evaluation my first semester, which empowered me with a method to examine and articulate my consequent lines of inquiry. I wish to thank my committee—Gretchen Adams and Bob Colby, and especially George Hein—for guiding me through my master's writing and encouraging me to continue this in the form of a book.

Alexander Goldowsky helped me get started, and Robin Mello helped me continue, and I thank them both for their expertise, interest, and vital assistance.

I also wish to thank my boss, Mike Alexander, for having the vision to put physics and theatre side by side. His work has allowed mine to flourish, and provided me with a stimulating laboratory in which to think and function. He has challenged and encouraged me in my pursuits and allowed me the time and space necessary.

Many thanks to all who spoke with me and contributed to this book.

My family set me up for this. All those years of telling me what a natural actress I was and taking me to museums worked its magic in an unlikely but fortuitous way.

Introduction

The power of theatre is its ability to reach the five-year-old as well as the eighty-five-year-old, to capture the attention of the kinesthetic and the logical/mathematical learner, to provide narrational and experiential entry points, to amuse, surprise, and impress. Theatre can open the senses and touch the heart and mind, challenging audiences' understanding and provoking them to rethink their own ideas.

Theatre is an appropriate and powerful educational and interpretive method for museums of all shapes and sizes as they move into the twenty-first century. This book aims toward an understanding of why that is so. It also proposes a definition of museum theatre, explores its foundations, and offers a glimpse of its future. This is accomplished through the deconstruction and examination of work at the Museum of Science in Boston and others in the field, as well as by tracking the threads of education, theatre, and museums from their origins to their convergence. Though science is the subject of most examples used in the book, other disciplines are examined as well. It is also in part a participant-observer qualitative evaluation in terms of how it looks at the Museum of Science's theatre program. As a participant-observer, I have endeavored to capture the essence of the work by keeping an observational journal during different projects. The idea behind this methodological approach was to provide an inside view of this work previously unseen. It also makes many passages in the book extremely personal.

This book presents examples of different museum theatre programs as well as frameworks for structure and style. Each is used to elucidate a point of theory or practicality. They are not to be taken as an exact method. I believe that museum theatre should develop organically, based on the needs and resources of individual institutions. Some museums have staffed theatre programs. Some museums use

theatre pieces developed outside their institution, but which add to an exhibition or event. Some museum theatre is never seen by an audience other than those creating it in dramatic workshops. I do not suggest that there is one way of doing museum theatre. It takes many forms. Museums are distinctly individual places and theatre is a versatile and bendable medium for all of them. Furthermore, I believe that current thinking in museums has laid a solid foundation for museum theatre to be more than an ephemeral curiosity.

1

A Day in the Bog

For visitors, museum theatre can be a surprising and exciting experience. What goes into creating this surprise? How is theatre integrated into exhibits? What does museum theatre look like from the inside as well as the outside? This chapter is intended to reveal the underpinnings of museum theatre, and in particular, one performance of the play The Bog Man's Daughter by Jon Lipsky (1993). This play is indicative of the style of play presented by the Museum of Science. During its ten-month run, it proved to be one of the most popular shows in the museum's then eleven-year-old Science Theatre Program. Visitor feedback provided an embarrassment of riches. At one point, the play received more positive comment cards than any other aspect of the museum. The performance detailed here took place in 1994.

The Visitor's Point of View

Imagine that you are a visitor to the Museum of Science, on your own with no particular agenda for your visit. As you enter the museum, there is a rack of flyers and brochures, including today's schedule listing possible programs for a museum visit. Included on this list is a reference to play performances of *The Bog Man's Daughter*, set in the Mysteries of the Bogs exhibition at 12:30, 1:30, 2:30, and 3:30.

The Bogs exhibition is located in a recessed corner of the museum's first floor. It was designed to show visitors the unique natural history, chemistry, and geology of bogs in Europe and North America. You wander through this exhibition with artifacts preserved in bogs and learn that the bogs contain information not available to archeologists in other habitats. The European section of the exhibition is filled with photographs, videos, and artifacts, primarily from Denmark and

England. Catching your eye, lying in a glass-fronted case, is a model of Tollund Man, one of the famous well-preserved bog bodies discovered by peat cutters. Tollund Man is believed to be at least two thousand years old. The acidic bog has preserved the corpse, with skin and hair still intact. Next to the Tollund Man's case, you can climb on a simulated peat bank with a painted landscape of an Irish bog.

On the other side of the peat bank, you can see several enlarged sepia-toned black-and-white photographs of Irish scenes from the turn of the century, including one of a young woman carrying a basket of cut peat. She is standing on a muddy bog in her bare feet, staring stoically into the camera lens.

In front of the peat bank is a bench on which to sit and rest a moment. It's dark and restful in this corner of the exhibition. A mother with two sons sits on the bench nearby and looks at the bog body. In another part of the exhibition, children are running around on the simulated quaking bog and throwing fake cranberries at each other. After a minute of sitting on the bench you notice, printed on a beige carpet underfoot, a drawing of the timbers of an ancient road on a bog.

A woman walks by the mother and her sons and opens a cabinet beneath the Tollund Man case. She is dressed in a worn-looking brown skirt and shirt with an apron and a wool shawl. After she opens the case, she takes off her shoes and puts them in. Her feet are brown and dirty. Suddenly, lights brighten the peat bank and backdrop. Music begins to play. The woman in the shawl turns to the visitor on the bench and others in the exhibition and calls out in an Irish brogue, "If you'd like to hear the tale of the bog man's daughter, you can come over here and sit in the corner." You decide to stay and watch the show.

Several more visitors come and sit down to wait and watch. One man speaks with an Irish accent. He points to several things about the peat bank and talks with his companion. As the music dies down, the woman in the brown outfit, now obviously an actor, begins reading from a tattered piece of paper. She's not very far away, within touching distance of some kids on the floor. She looks directly at people. Some visitors look away, but most return her eye contact. She's talking about her brother in Ireland and how he wants her to join him in

2

America. Her brother is in Lowell, Massachusetts, which reminds the visitor that Lowell's mills were once worked by Irish immigrants. The actress says something right off about being in nineteenth-century Ireland. A song begins to play from somewhere and she sings along to it about why she loves the bogs. It's lilting, soft music, and everyone is quiet. As it finishes, the actress jumps into a story about her father and his job cutting peat. It changes the mood completely. She grabs a long shovel called a *slaene*. She demonstrates how her father cuts peat with it and even gets a child up from the audience to help her set several pieces of peat into a stack for drying.

When they finish, there is music again but this time it is more lively, and the actress begins to dance. This is how she and her family celebrate the end of the peat harvest. The lights are changing slowly. The children running on the quaking bog stop and hang on the railing to watch. It gets darker, and an orange light is cast on the Tollund Man model in the case. The actress creeps over and tells of how peat cutters come across bodies like this, bodies so well preserved the cutters think they've come across a recent murder victim. She laughingly recounts how one man actually confessed to murdering his wife after they dug up a body. It wasn't her body at all but an ancient one. The husband went to jail anyway. Everyone laughs with her. It is then that you notice there is eerie music and sounds playing. As she looks at the Tollund Man, the actress recites a piece of Seamus Heaney poetry, beautiful and mysterious. The lights come up and she asks if anyone has heard of the Boogie Man. Almost everyone nods their head yes. It's then that you realize that *that* is where the term comes from—the Boogie Man comes out of the Bog! The woman then tells of how superstitious her grandmother is about the "Boggie Man," as she pronounces it. She humorously imitates her Gaelic chant that sounds like no language you have ever heard before. The chant is supposed to ward off evil. The actress ends up standing beneath what you can now make out as a piece of thatch roof jutting out from the wall next to the peat bank.

The actress promises to tell the story of the Boggie Man and the tailor. She arranges a cast-iron kettle, a pan, and some of the peat and sits down with her shawl over her head. Several children already look scared as she begins, though no one moves. It is now very dark. The story is a familiar tale of boys daring each other into doing something

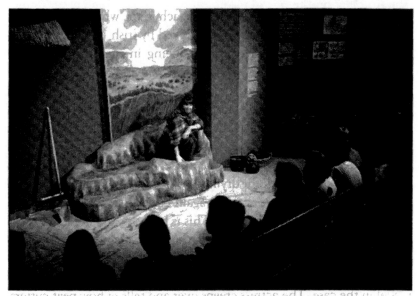

Figure 1-1. *The Bog Man's Daughter.* Photo by Eric Workman.

silly—in this case, staying all night in a haunted old church. When confronted with the Boggie Man, Timothy the Tailor saves himself by jumping into the graveyard, hallowed ground that the Boggie Man cannot enter. In his anger, the Boggie Man throws his own head over the wall and where it lands, a spring bubbles up. As the actress says this, she pours water from the kettle into the pan below. The sounds end suddenly. She looks into the water in the pan, looks out at the audience, and finally says she still doesn't believe in the Boggie Man. Several people laugh and the lights brighten.

As she cleans up the kettle, the woman talks about her brother again and how she doesn't want to leave the bogs. She describes how good the bog can look with its flowers and frogs and rabbits. Again, the language is very poetic. This leads right into a song. As the actress finishes the last notes of the song, the lights dim and then go to darkness. The audience applauds and when the lights come up, she takes a bow. She tells everyone that they can come up to touch the peat or talk to her. Several people do. You and other visitors get up and continue your visit to the Bog exhibition.

4

The Actor's Point of View

Many people have been on the receiving end of such a museum experience, but few have been on the other side. Consequently, the work of presenting museum theatre is filled with mystery and speculation. What is it like to do this? It does hold some mystery, but it also involves basic skills and commitment. My job at the Museum of Science is to act in plays in exhibitions or in its theatres and to be a museum educator. I am expected to be as committed to my acting as I am to creating a learning experience for the visitor. I must be believable as any character I play, and be able to handle questions regarding rest room locations. I am a professional hybrid.

On this day, as I enter the Bog exhibition in costume to do my 12:30 show, I observe visitors milling about, looking at the exhibit. I walk through to the back of the exhibition to my stage and unlock the cabinet. A family of three, a mother with a teenager and a seven-year-old son, is sitting on one of the benches and reading the label above the Tollund Man. The mother asks if the younger son would like her to read this aloud. The boy asks if the body is real. I turn to them and say, "If you want, you can hear the story about him. I'm going to be doing a play right here." The mother tells me that the younger boy is very interested in the "boogie" man. At this point, no one else in the exhibition seems to have noticed me. Some visitors may have read the sign next to the stage giving such information as the title of the play, when it is, who wrote it, who will perform it, and a one-sentence description. I hit the switch to turn on the computer, and the stage lights suddenly brighten my peat bank stage.

The entire stage is only six feet long and two feet wide. Most visitors do not realize it's a stage until I announce the play, which I bellow in a loud brogue, *"If you'd like to hear the tale of the bog man's daughter, you can come over here and sit in the corner."* I always speak in the accent of this character before the show. It is a personal choice. I do not do this with every character I play, but feel in this instance that the difference between accents is too jarring. I've also found that visitors are attracted to the Irish sound. And though I am then playing the character, I still answer logistical questions. I am not yet in the

reality of the play. Several people head in my direction. The wooden benches for the audience do not seat more than ten people, so I usually encourage children to sit on the floor by saying that there aren't a lot of seats out on a bog. I then go out into the main hall of the museum and make an additional announcement for the play. This nets a few more visitors. Though the performance times are listed on the printed daily schedule, I usually have an announcement made over the public address system about five minutes before the show to reinforce my potential audience. My entire audience is sixteen people, average on a weekday, as I begin. Weekend audiences are usually larger, potentially growing to as many as 80 to 100 people. During these shows, the audience takes up every inch of space in this corner of the exhibition, occasionally encroaching on my performance space. From where I look out, there is a sea of faces.

The computer cues two minutes of taped background music on the sound system, while I set up the stage with my props as people sit down. When the music fades, I begin to read a letter silently, walking back and forth in front of the audience. As I read, I look up at them and mutter that it's a letter from "me brother." The audience takes this as the cue that the show is beginning. They quiet down to watch.

I squish my face in disbelief at what I am reading in the letter and look up, speaking to the first audience member my eyes fall on. To a young girl, I say, "*I'm nobody, who are you?*" Before she has a chance to reply, I continue, "*Are you nobody too?*" I look her in the eye, smiling, and put my hand out protesting, "*Don't tell, they'll banish us you know.*" She squirms and smiles. Then I look around at others in the audience, "*How dreary to be somebody, how public like a frog.*" I look at the letter again and recite, "*To tell your name the livelong day to an admiring bog,*" ending with my arms outstretched to the exhibit. I wink at the child I singled out and laugh, "*That's a poem*" and I read from the letter, "*by the great American poet, Emily Dickinson.*" With this moment, I always try to reassure the person I single out that they have been part of my fun, not the object of it.

Continuing, I hold the letter out to the audience,

Me brother put it in his letter, just to make fun of me. He thinks I'm wasting my life, telling me name the livelong day to an admiring bog.

"Why don't you come to America," he says, "and be a factory girl in the great cotton mills of Lowell, Massachusetts? Wake up, sister, this is the nineteenth century!"

I look up from my letter, wondering with the audience, Is he right? I shake my head, making up my mind. *"Well, he can take his nineteenth century and stick it."* There are some chuckles at this.

Thus the conflict in the play has been set. I have established that my character lived in the nineteenth century and that she wants to stay in Ireland, rather than join her brother in America, and she is obstinate and earthy. The rest of the twenty-minute play consists of her stories of life on the bog.

As the character Deirdre, I assume the crowd before me to be visitors traveling through the bog. I sing of my love for the land, recite the poetry of famous Irish bards, pepper the audience with questions about their knowledge of peat, recount poor Mrs. McConnell's unfortunate losses in the frightening "bog burst," weave the yarns of my Granny's belief in the legend of the Boggie Man, chant her Irish incantations, dance in celebration of the end of the peat harvest, and finally decide I will never leave this beautiful land, at least not in my heart.

As I sing the last note of my song, the lights come down and the audience applauds. I wrap up by saying in my own voice, *"I hope you enjoyed the show. It's all part of the Science Theatre Program at the Museum of Science, so if you have any questions or comments, please come and talk to me now, or write your comments on comment cards by the information booth as you leave. You can come up here and touch the real piece of peat now if you'd like."*

I have found this moment immediately after the play to be one of the most surprising and rewarding. This is when visitors tell me what the play made them think about or something that struck them. It's really one of the great aspects of this work. How many people get immediate feedback about how they're doing at their jobs? I make myself available as I clean up the stage, now as Catherine rather than as Deirdre.

On this occasion, a boy around twelve wearing a ski cap walked up and pointedly asked, "Is that the way you really talk?" I said that I

don't and that I'm from Boston. He shook his head and whistled, "Jeez, that's good acting." There have been quite a few native Irish coming to see the show and they always want to talk about life there, which in some cases hasn't changed much since the time of the play. Occasionally they'll give me a different pronunciation for a word or phrase. I've learned how differently each county of Ireland speaks. One Irish boy was amazed that we would do a play about *turf*. He said, "It's just turf," as if we in America were daft to not know about it! Many people who come up want to tell me about memories of their immigrant grandparents. Americans often make connections with peat moss and gardening and are surprised that there are more than cranberry bogs in the United States. Following a play, there are con-nections being made, concepts being explored, feelings being expressed. An experience has been had.

A colleague in the museum theatre field once commented to me that museum theatre is as much about the experience as it is about the information. I took *experience* to mean something difficult to describe, an intangible happening between the performer and the visitor. It is that dual feedback, that continuing dialogue with the visitor that sep-arates this from other experiences in the museum. For example, on another occasion a little girl, about two or three, stood in the middle of the floor between the stage and the benches as I was putting my props back into the closet. She stared at me and I asked her if she was going to stay in the bog. She said no and asked me if she could shake my hand, holding up her left hand. We solemnly shook, my right hand to her left. Smiling, she walked over to her family and whispered loud-ly that she had touched me.

She seemed thrilled to touch me, to find out that I was real. Other children have come back to see this play for a second or third time, and they introduce themselves to me as though we are friends, "I'm So-and-so, remember me?" I am surprised by visitors' impact on my experience. It is very satisfying for me and, I hope, for the visitor. This little girl's request to shake my hand meant as much to me in that moment as a glowing review in the daily paper. Perhaps she will carry the memory of our touch and the show that preceded it even longer.

Children can also be critical observers. After another show, sur-rounded by children from a school group, a boy pushed through to ask

me where I was from. When I replied Boston, he snapped his fingers and said, "I knew it! 'Cause I heard you lose your accent sometimes, you did, you know." Instead of being defensive about this, I laughed with him. Though I use the accent, I am not there to fool anyone into thinking I really live in Ireland. I want visitors to understand that I am an actor in a play, and a member of the museum staff.

2

A Personal Journey
From Theatre to Museum Theatre

Juxtaposing my own personal journey with the advances in museums and theatre, in this chapter I chart my dawning awareness of the possibilities the two fields offer.

I believe that museums *are* theatres, rich with stories of human spirit and activity and the natural forces of life. Theatre and museums are storytellers, tapping into an elemental human consciousness. Both museums and theatre present us with ourselves in different contexts, holding the mirror up and showing us what we have done and what we might do. This idea of the museum as storyteller is not new, but recently it seems to be emerging into the full light of day. Now institutions like the U. S. Holocaust Memorial Museum in Washington, DC, address the idea of storytelling explicitly, preserving the memory and experiences of a generation to pass on to the next. The Holocaust Museum tells the story of what happened to people during World War II through artifacts such as shoes and photographs. The narrative thread is maintained through use of identification cards given to each visitor, which allow them to follow the paths of actual individuals from homes to camps to the end of the war. The fate of the individuals is not known to visitors until the end of the exhibition experience. It is a paradigm shift and makes evidence and scholarship problematic rather than self-evident. An object can tell different stories, rather than only one. And so museums do not necessarily start with the object and choose bits of its story as context any longer; now it can be the memory or story, as with oral history, which is then supported by

the choice of objects. This is radical. Methods must be found to help museums on this present treacherous course.

Theatre can help. It provides opportunities to question knowledge, to approach ethical dilemmas, and to explore ideas from different perspectives. In this light, I believe that theatre is an efficient tool for revision and diversity, contextualizing information in a way that is imperative for museums at this point in history. Museums are being challenged by various sections of the public regarding these ways of seeing, evidenced in the Enola Gay exhibit controversy, and exhibition methods beyond object display and labeling such as theatre can further articulate the issues being presented.

Theatre can also provide learning opportunities for a wide range of learners. There is music, movement, spectacle, humor, pathos, and poetry, all of which tap into the multiple intelligences theorized by psychologist Howard Gardner. Visitors can be empowered to take away a personal and meaningful experience through interaction with an actor playing a character or by watching a play (Jones 1993, 62). Drama and museums can provoke and motivate the desire to learn. Because of all of this, I believe museums need theatre in order to be more accessible as social institutions, more effective as educational institutions, and more honest as cultural institutions.

One surprising aspect of my theatre work at the Museum of Science, Boston, has been to find the hidden narratives in science. On the wall of the Museum's Mathematica exhibition, there is a time line of the history of mathematics with pictures and descriptions of the great mathematicians. The wall is old now and needs updating. Increasingly, visitors voice indignation at its inequities on comment cards. Not surprisingly, there are few women or minorities honored. There is one person's story missing that could go into the early 1800s. It is the story of a young woman with an unquenchable desire to understand and articulate the meaning of the world around her. Published anonymously in 1843, Ada King has gained fame 150 years after her life, honored by the United States Department of Defense with a computer language in her name: ADA.

Ada Byron King, countess of Lovelace and daughter of the poet Lord Byron, had been a mathematician in the male-dominated early

11

nineteenth-century scientific world. Through her work with her mentor, Charles Babbage, father of computer theory, she is now credited with being the first computer programmer. She was a visionary, writing of the possibility of composing pieces of music on the future computer. She was also quite a personality, as passionate about horse racing as she was about mathematics. Ada lived in the shadow of her infamous father and worked hard to "shine a light even brighter" than his, excelling in the art of mathematics rather than poetry. Still, she had poetry in her soul, and her surviving letters provide us with a resonant view. They are rich with poetic images: "Reading mathematics is like rereading God's work" (Toole 1992, 247).

Her chosen language was mathematics, in a day when women were thought incapable of thinking algebraically. When they did, it was believed the activity might physically harm them. Ada was counseled by her tutors to desist in her studies, which they believed were making her ill. She was, coincidentally, sick throughout her life, at one point becoming addicted to prescribed opium and morphine. She finally succumbed to 'cancer of the womb' at the age of thirty-six. There was no evidence that numbers ever caused her sicknesses. They were, instead, her joy. An indifferent mother of three by age twenty-eight, Ada described her only published paper on Babbage's computing machine in maternal terms: "This first child of mine is an uncommonly fine baby" (Toole, 211). She was precocious, brilliant, and given to flights of fancy. A century and a half later, playing Ada, I became a missionary to the history of women in science, using the play as a revisionist tool.

I have been an actress most of my life, performing at home, then school, and finally in theatres. I do not recall wanting to be anything else. At seven years old, I wrote my own play version of *Sleeping Beauty*, borrowing the dialogue from a coloring book. I enlisted my friends to play the supporting parts to my Sleeping Beauty, and set it in the natural amphitheater of a neighbor's backyard. We charged five cents admission. It was a smash hit. Upon graduation with a bachelor's degree in theatre, I convinced myself that I was willing to undergo years of rejection and little financial gain in order to be ready when my

big break came. My romantic picture of the big break was getting the lead role in an exciting new drama opening off-Broadway. Then I would do Shakespeare, Chekhov, and Mamet in repertory. I never reflected on the meaning of theatre, never questioned its power. Instead, I worked to improve my acting and learned the business of a theatre career, faithfully auditioning for absolutely everything.

My theatrical vision transformed after I auditioned and was hired to perform short vignettes for the Museum of Science's Omni Theater. Though these ten-minute skits were far from Shakespearean, I was proud of being paid to do theatre. The project was directed by Davis Robinson, a local theatre director, and managed by Mike Alexander, on staff of the Museum. The educational goal was to prepare visitors for the experience of the Omni Theater, while keeping them entertained as they waited to enter. I enjoyed performing in these skits; the public laughed and clapped and perhaps even learned something.

During this time, Mike Alexander decided to produce a theatre piece to augment the traveling exhibition Women in Science. Mike had been exploring the use of theatre in various locations in the museum and in various programs. The year before, the museum had successfully produced a play with an exhibition called The Mary Rose (Hein, Lagarde, and Price 1986). The Women in Science exhibit provided a clear opportunity to use theatre to highlight the challenges historically faced by women in science. In his research, he found the perfect subject: Ada Byron King.

With Ada and the continuing Omni presentations, the Science Theatre Program began in earnest, which in turn changed my perspective and view of theatre. In 1988, I began performing the 35-minute play Ada: Bride of Science. Ada's spirited and tragic story inspired me, leading me deeper into museum theatre, and eventually changing the course of my theatre career. The character of Ada is an actor's dream, full of contradictions and desires. The play was drawn from her letters. My research included reading several accounts of her life and work, as well as her own words. She jumped off the page and into me.

The self-reflection that had been missing from my theatre work and ambition up to this point emerged after I played Ada. I became aware of a sense of purpose. I wanted and needed to tell her story.

In London

A year later, I had the good fortune to play Ada in The Science Museum in London. I performed beside a small portrait of her, painted when she was a young woman. I felt somewhat humbled portraying Ada in England so close to her home, where the public knew more of her than did North Americans. However, I found that though people generally recognized her, it was due to the fame of her father, and not so much her scientific achievement. My sense of purpose remained.

During ten months in England, I was able to see how another museum used theatre. Rather than perform on a set schedule as I had in the Boston museum, I changed my performance as Ada to the more fluid gallery style of the London Museum, performing in the computing gallery whenever a crowd gathered. I performed a set script of approximately fifteen minutes, which I had adapted from my previous show with the assistance of the manager of Spectrum Theatre, the museum's drama programme, Geraint Thomas. In between these short performances, I improvised with visitors on a one-to-one basis. I would remain in the gallery for seventy-five minutes, take a half-hour break, and then return for another hour.

The two museum theatre programs were quite different in structure and style but served the same goal: to educate visitors about scientific topics using theatre. In Boston, I was used to a more structured performance area, where visitors either sat down in a theatre or waited in lines to watch. We used microphones, lights, and sound. In London, the focus is on the actor in character in relation to specific objects without any theatrical accoutrements. Because I was not always performing a set script, visitors interacted more directly with me, creating more of a flow between actor and visitor.

The tangible focus of my performance in London was a piece of the Analytical Engine, predecessor to the first computer, designed by Babbage. I performed next to it and often talked about specific aspects. I was occasionally challenged by enthusiastic mathematics buffs to defend Babbage's or Ada's ideas. In London, there was more preconceived knowledge of Ada and Babbage than in Boston, so that my task was different in these two cultures. In Boston, I was giving visitors

entirely new and surprising information. In London, I was sometimes adding to or changing a visitor's understanding.

They were both flourishing, professional programs. My fellow actors in the London Museum were, for the most part, in the Actor's Equity Union. They were slightly older, seasoned veterans working in other plays outside the museum. A few of them, such as Geraint Thomas, the manager, were trained in theatre-in-education. This training related directly to what they were doing out in the galleries, giving these actors a particular understanding of the work and sense of purpose.

In Boston, everyone was hired from the Boston theatre community, though not necessarily union actors as in London. Union work in Boston is scarce, so there are fewer union actors than in London. Many actors had had some experience with children's theatre, which was considered a plus when looking at resumes. Aside from talent, which was important, actors were hired for their maturity, required by the program's autonomous nature. Actors had to be able to handle performing shows without support staff. This was also necessary in London.

The professional atmosphere in London created a sense of competition, which gave an edge to people's work. The actors looked at each other's performances and gave each other feedback. It kept people on their toes. This aspect of professionalism was still being developed in the Boston Museum at that time. I returned to the Museum of Science with a more complex understanding of museum theatre work, a broadened point of view, and new zeal.

Back in Boston

I had found my *raison d'être* with museum theatre and became convinced it was a valuable undertaking. My dramatic work continued, but I also became curious about the theory behind it. I began to seek information and documentation to back my beliefs that theatre has the ability to educate in museums, that it is important to include in the roster of interpretive methods, and that visitors will remember their dramatic experience long after their museum visit.

Backing up such claims requires more than curiosity—it requires research. Hence, I studied qualitative research and evaluation methods.

I had been collecting anecdotal evidence and began conducting small systematic studies. These suggested to me that theatre is a fun learning experience that engages visitors' emotions. I have continued to pursue research into museum theatre, which has led me to ask new questions. What do we mean by "learning"? How do emotions affect memory? It's a winding but inspiring avenue to follow.

As the Museum of Science's Science Theatre Program has grown, I have evolved from an actress in a museum play into a museum professional who acts, directs, writes, and administers it. I have found an exciting, rewarding venue where I test my creative dexterity on a daily basis. In my current position as the Science Theatre Coordinator at the Museum of Science, I deal with day-to-day issues such as scheduling as well as the development of future projects.

When I returned from London in 1990, with support from the Museum of Science and museum theatre colleagues, I founded a membership organization for those doing theatre in museums called the International Museum Theatre Alliance (see Appendix 1). My missionary zeal now went beyond the walls of the Museum of Science. I wanted more museums to get on the bandwagon. My contact with peers in the field has allowed me to better articulate my own sense of the work, while gaining insights from the myriad and divergent programs that exist today. It has been stimulating, challenging, and fulfilling to be part of a movement that has the potential power to change the face of museums as we have known them and to contribute to expanding the ideas of theatre and education.

There is some irony to the fact that I do theatre in the Museum of Science. First of all, I grew up fairly science- and math-phobic. I was the kid who penciled in pretty pictures with the answer circles on my mathematics SATs. I did not look out at the stars and wonder who or what was out there. I did not work out juvenile experiments in the backyard. And here I am trying to inspire these qualities in others. Second, I had an experience in the Museum of Science when I was on a sixth-grade school visit that made a deep impression on me. Many other museum people report of an experience they had as a child with a real object and how this set off their desire for learning (Csikszentmihalyi and Hermanson 1995, 35). My experience was not

with an object, but in a live demonstration. I was picked as the volunteer from a group of more than a hundred of my peers. I was hooked up to an EKG to monitor the beats of my heart. The demonstrator then asked me alternately boring or embarrassing questions. They were innocuous, but embarrassing all the same to a twelve-year-old. My heart responded by beating faster and slower. The finale of this demonstration, which would hardly be allowed in today's culture, was two male educators coming up behind me as I read a very boring piece of literature and kissing me on both cheeks. My heartbeat jumped off the monitor! Following this episode, I enjoyed a dreamy but brief period of exceptional popularity. The quality of this experience has never left me, and I think of it often as I interact with visitors to the museum.

3

The Nature of Museums and Theatre

What is it in the nature of museums and the nature of theatre that makes their merger so appropriate and complementary?

Museum Theatre is equal parts theatre and museums. To get to its root nature, we have to wrestle with both disciplines. What is theatre and what are its aims? What is a museum and what are its aims? These are, of course, huge questions about which scholars and practitioners have been writing and arguing for years, or in the case of theatre, for centuries. Since both mediums continue to evolve, in effect what we are grappling with are changes within these two fields. These changes are opening opportunities for each. Theatre can help museums address some of the current issues facing them, while museums are providing a new frontier for theatre. Changes in museums are the initial focus of this chapter. There are three overarching movements of thought influencing these changes: the history of presenting one view, where artifacts are truth; the view of truth as relative and a need for context; and the growing prominence of education and communication. In order to begin at the beginning, an abridged look at both the worlds of theatre and museums first.

Brief History of Museums

The Latin word *museum* comes from the Greek *mouseion*, "shrine or temple to the Muses," the nine daughters of Zeus and Mnemosyne. I find this root particularly appropriate when addressing museum the-

atre as the Muses presided over poetry, epic, music, love, oratory, history, tragedy, comedy, the dance, and astronomy. We might not know exactly what the function of such a *mouseion* was, but it is satisfying to think of all that art and science under one roof! It is also encouraging to think that theatre in museums might be evidence of a cyclical journey—it's coming around again.

In his book *Museums in Motion*, Edward Alexander (1979) traces the ancient prototypes of museums with roots in research libraries and lecture halls, laboratories, and scientific studies, through the birth of private and public collections in the sixteenth to the nineteenth centuries, up to our present-day modern museum. Neither Alexander, nor author Eilean Hooper-Greenhill (1992), in her book *Museums and the Shaping of Knowledge*, traces the aim of museums in a linear pattern from one clear mission to another. Research and scholarly pursuit, collection and conservation, exhibition and education, have all gone in and out of fashion (Alexander 1979, 8-10). Collecting has maintained an important place in the function of most museums, though the choice of objects to be collected has varied greatly based on contemporary societal values.

In his book *Rethinking the Museum*, Stephen Weil (1990, 55) traces the root of a new museum paradigm from Joseph Veach Noble's earlier ideals in his 1970 "Museum Manifesto," in which Noble describes the five basic responsibilities of every museum: to collect, to conserve, to study, to interpret, and to exhibit. Based on this prior conventional wisdom, the new paradigm's essential wording would include: to preserve (*to collect* being viewed as simply an early step in the process), to study (a function that remains unchanged), and to communicate (this third function being a combination of Noble's final two, *to interpret* and *to exhibit*). From this last fusion, the responsibility of museums to find ways to communicate with visitors has never been so prominent.

In reviewing the development of museums in the last century, one experiment interesting to note is Skansen, the first true outdoor (open-air) museum exhibiting artifacts in their cultural contexts (Alexander 1979, 10; Anderson 1984, 19). Artur Hazelius established this national center in 1891 in Stockholm, Sweden. Though the idea for such a historical cultural center itself was a new one, Hazelius

added another component: people in the exhibitions. "Without activity," he felt, "Skansen would be nothing but a dead museum, a dry shell of the past" (Anderson 1984, 19). These pioneer costumed interpreters and musicians were taking historic steps toward the creation of drama on Artur Hazelius' perfectly theatrical environmental stages.

Current Museum Theory

In recent years, the shift is toward museums' educational function. Addressing this, Hooper-Greenhill writes: "Knowledge is now well understood as the commodity that museums offer" (2). Viewed as a necessary supplement to schools or sometimes as the cure to ailing public school systems, museums are acknowledged and sometimes justified as educational agents. American museums began in theory with an educational function, though the actual practice lagged until much more recently. In *Museum Education: History, Theory and Practice* (Berry and Meyer 1989), the authors assert that "the mandate for education was fundamental to the founding of art museums in this country, especially in this century" (29). Practice is now catching up with that theory.

The educational concern today may be attributed to several causes. First, pragmatically museums are in need of relevance in today's society, and in this case, to be educational is to be considered relevant. In order to attract visitors who have many demands for their time and especially to attract increasingly scarce funding sources, museums must present themselves as something people need. In successive reports, the American Association of Museums (AAM) has counseled museums to focus on education. In 1984, the AAM's report *Museums for a New Century* made the recommendation that "education is a primary purpose of American museums" (31). In 1992, the AAM's report *Excellence and Equity: Education and the Public Dimension of Museums* "differs from the earlier reports in placing education, broadly defined, at the heart of nearly everything a museum does" (O'Connell 1993, 1).

Most museums now include educational language in their mission. For example, the stated mission of the Museum of Science is to

stimulate interest and further understanding of science and technology and their importance for individuals and society. To accomplish this

educational mission, the staff . . . are dedicated to attracting the broadest possible spectrum of participants and involving them in activities, exhibits and programs, which will:

- encourage curiosity, questioning, and exploration.
- enhance a sense of personal achievement in learning.
- respect individual interests, backgrounds, and abilities and
- promote lifelong learning and informed and active citizenship. (Museum of Science 1991)

In this age of deconstruction, the new focus on education has rattled the foundations of museums by bringing up questions about how we view knowledge, how we perceive the learning process, and how we determine whose point of view is dominant. What is it that museums are trying to teach visitors, and how are they doing this? These questions are changing how museums function. There is also a connection between this educational shift and Hazelius' contention that without people a museum is a dry shell. Today people such as interpreters or demonstrators are once again considered necessary to connect the visitor to a museum's collection or ideas and to create an educational experience. Furthermore, an individual visitor's experience in a museum has value, which in turn encourages museums to make themselves educational for a variety of visitors. The choice of educational message is vital, as is the way in which it is presented. In the greatest shift, museums are no longer promoting themselves as expert authority. There is an awareness of the individual and the individual's experience, rather than the museum's identity and power.

Thus, the idea of knowledge in a museum is changing. "Just as rationality is not absolute, but relative and shaped by culture, so what counts as knowing has varied across the centuries" (Hooper-Greenhill, 12). This has a direct relationship to the idea of museums as storehouses of tried-and-true knowledge and in turn plays into an important goal for museum theatre: to turn a self-conscious eye on museums in positive, creative ways. The traditional view of museums in this century has been from the realist's standpoint, as a transmitter of truth and knowledge that has been tested for legitimacy. Philosopher Michel Foucault's theories turn this topsy-turvy. In *Museums and the Shaping of Knowledge*, Hooper-Greenhill examines Foucault's approach

to history and relates it to museum theory. "Foucault understands reason and truth to be relative, rather than absolute concepts, and he proposes that both reason and truth have historical, social, and cultural contexts" (9). For museums, this idea allows the belief that they do transmit knowledge and truth, but obliges museums to acknowledge that *that* truth and knowledge are relative to time in history. Rather than an omnipotent truth, an exhibition has a point of view in a certain time. Additionally, it calls into question previous concepts of truth and knowledge. A new form of knowing, based on questioning why things were the way they were, comes out of Foucault's reasoning (18).

Such philosophical shifts are influencing the ways in which museums develop exhibits. The Art Institute in Chicago offers Art Inside/Out, a permanent exhibition of objects showcased from its stored collection. Introductory panels address questions concerning how and why the Institute chose these objects, i.e., the viewpoint of curators made explicit. The Museum of Science arranged a glass case with historic artifacts from its collection with three small labels:

- People collect things from nature for many reasons: for research, as trophies, as souvenirs from a trip, to make a product, or simply to be admired.
- These objects were collected before we understood that the world's resources are limited.
- Today, it would be considered unethical or illegal for individuals to collect these objects.

There is a bulletin board with this question, What do you think? This case is juxtaposed with the entrance to the Colby Room exhibition, a replica of a 1920s Gun Room decorated with hunting trophies and memorabilia. Today visitors flinch at the political incorrectness of this room, but at one time it was considered perfectly appropriate.

For Foucault, history is not a straight unblemished line. To gain insight, Foucault suggests "effective history," a view of the past that emphasizes differences rather than similarities, error rather than accuracy, change rather than continuity (Hooper-Greenhill, 10). For example, what practices or beliefs in another time have come to light as misguided or wrong? For Hooper-Greenhill, "Focusing on when and

how 'museums' in the past changed, and in which way and why long-standing practices were ruptured and abandoned, may provide a context for today's apparently all too sudden cultural shifts" (10). Emerging from these ruptures and upheavals, Foucault describes three major epistemes: the Renaissance, the Classical, and the Modern. Each age has its own structures of reason and rationality, and moving from one to the other meant the complete rewriting of knowledge (12). Hooper-Greenhill interprets that in Foucault's modern episteme, our current day, the role of the museum changes radically from what was deemed reasonable in the previous times. Not only does the museum exhibit objects, but it must contextualize them. "In the modern age, the function of the museum is to research and demonstrate the social and cultural context of artifacts and to foster relationships between objects and people" (19). Thus, museums become object storytellers in Foucault's "modern age," answering the who, what, where, and how of the object. Narrative drives exhibition design. In this light, the progression from the museum as a theatre to the practice of museum theatre is a natural one.

Hooper-Greenhill identifies the focus on themes, ideas, and relationships as one of the guiding forces of the modern museum. In support of this, she quotes the mission of the Musée de la civilisation in Quebec City: "While many museums focus on the artifact, the Musée de la civilisation focuses on the human being. Artifacts, however important they may be, are only so because of their meaning and use. They are seen above all as evidence of human activity" (Trudel 1989, 68). It is this shift in focus, to the human being, that theatre can help express or bring vividly to life. The story of the human connection needs to be told and placed in context.

Museums are places of change. "Museums are inventions of man, not inevitable, eternal, ideal, nor divine. They exist for the things we put in them, and they change as each generation chooses how to see and use those things" (Adele Silver quoted in Weil 1990, xiv). Currently, change in museums is not only evident in education, but in terms of cultural thought. Both education and cultural thought are, in turn, influenced by shifting demographics. This is playing itself out in very public arenas, such as the *Boston Globe* newspaper, which ran an article reporting the dedication of the newly renovated museum at the

John F. Kennedy Library. The reporter pointed out that nearly everyone on the podium for this event was white, as is most of the board of directors for the Kennedy Library. In response, a spokesman for the library acknowledged this as a problem and reported that changes were being executed. The *Globe* reporter put it succinctly:

> Museums face a dual challenge as they redefine their missions for the coming millennium: First, they must reinterpret their exhibit halls to make them accessible to a wide and ever-changing population; and second, they must find ways to reflect and reach out to the communities in which they reside. (Hartigan 1993)

North American demographics have been changing rapidly, away from the homogenous standard that museums seemed to be representing. Collections of wealthy people's art and artifacts do not reflect poor people of any race. Museums are no longer immune to the need for recognition of this shift. Nearly twenty years ago, voices were demanding that museums take notice of the people around them. Museum professional and author Edward Alexander quotes the Afro-American poet June Jordan as one voice:

> Take me to the museum and show me myself, show me my people, show me soul America. If you cannot show me myself, if you cannot teach my people what they need to know—and they need to know the truth, and they need to know that nothing is more important than human life—if you cannot show and teach these things, then why shouldn't I attack the temples of America and blow them up? (Alexander 1979, 6)

The important debate into the cultural identity of museums, about who is represented and how, has created many passionate dialogues in the museum world. Objects are no longer assumed to have a single meaning. This is particularly clear when it comes to collections amassed from foreign soil, as in The British Museum's mummies and Rosetta Stone. There is the meaning of the originating culture and the meaning of the exhibiting culture, and indeed, possibly others. Referencing papers and discussions from the 1988 Smithsonian conference, The Poetics and Politics of Representation, Ivan Karp (1991) summarized the arguments: Is an object or the context of the object to be highlighted? The aesthetics of the objects or the prepositional

knowledge about them? and Is a curator's message about the history of an object and its original context more authentic than the provenance of the object itself? (12). Obviously, there are several different perspectives to consider when interpreting such objects.

Whose reality has been offered in museums? Museums have been listing under a value-laden and often elitist masthead, though not without some self-awareness. This can be evidenced by a multitude of museum conference sessions on repatriation, ethnicity, diversity, and cultural issues, and by publications such as *Museum News*, with its March/April 1995 cover story, "Museums in an Age of Uncertainty."

I was fortunate to hear Juanita Moore, at that time the executive director of the National Civil Rights Museum in Memphis, speak to the future of museums at the American Association of Museums annual meeting in Fort Worth, when she pointed out that we have been discussing change for the last thirty years and yet nothing has really changed (Moore 1993). She challenged people to accept real change and charged them to move past "old" language. This goes back to the idea that we must move beyond the rhetoric of theory and begin effective practices. In the same session, John Kuo Wei Tchen, director of the Asian/American Center, Queens College, New York, called for us to "expand our views from elite caretakers of elite collections," and to question who the "we" is expressed in our collections (Tchen 1993). Again it is the question of whose meanings a museum should embody.

This shift, from the object as separate from people to the object as representative of people's stories, is a challenge facing museums today. It is also where museum theatre can take a proactive role by providing a way to confront these issues. The struggle over whose voice should be heard regarding an object is a difficult topic for museum professionals to discuss in conference forums and certainly one visitors might not want to approach on a family day out. However, set within the context of a play, a discussion over object meanings can provide enough distance to become safe and approachable. Visitors can place their minds within the conflict of the play without threatening themselves. This is not a given. Just using theatre to address these issues does not guarantee success. Theatre with this content must be subtle. Banging a visitor over the head with a message will only serve to concuss their mind, not expand it.

Theatre must not become another didactic tool for museums. It can and should do more than that, and it possesses the ability to move beyond established museum functions. One of the stated goals of the Canadian Museum of Civilization's live interpretation program is to give an added dimension to the traditional museum experience by using the performing arts to interpret aspects of heritage more effectively than static objects (Alsford and Parry 1991, 11). The Central Ohio Museum of Science and Industry (COSI) displays its museum-exhibit developers in action with glassed offices through which the public can view them at work. What was once a mystery to the visitor is very often being exposed. At the Powerhouse Museum in Sydney, Australia, theatre was used to try to provide visitors with new ways of seeing the museum. A small school of actors figuratively swam through the exhibit halls in slightly offbeat swimming costumes attracting the attention of visitors, leading them to cases and objects like the Pied Piper. As the actors carefully and silently examined the exhibits, they encouraged visitors to do the same. These exercises reveal a growing trend in museums to reexamine the very nature of museums, and theatre is a powerful tool to communicate such complex ideas in a provocative yet safe environment.

It is clear that museums are being modified by contemporary society. Most, though not all, museum professionals no longer believe it is all right to house artifacts under glass without labels. Though many might disagree to some extent, museum educator Arthur Parker is of the opinion that "people want to be entertained by exhibits, sights and sounds. They want sensory stimulation. They want to be thrilled by what they experience in a museum, not merely bored by long labels, no labels, or crowded cases. . . . They want a feeling of personal contact" (Berry and Meyer 1989, 37). Similar to schools that accept Dewey's child-centered philosophy, museums are becoming more visitor-centered. The push for diversity and multiculturalism is a natural extension of the realization that museums must allow for all views and that knowledge is deeply influenced by culture. It is also true that museums face a challenge to be relevant in this multicultural world and need those diverse audiences to survive.

There are related changes happening in how museums define education and visitors' expectations and views on learning. Museum pedagogy is changing. The concepts of "meaning making" and "construc-

tivism" have gained prominence. I address these issues of learning and evaluation in Chapter 12, but for now, a central question is whether museums are trying to educate visitors with the empty-vessel teaching approach or are they attempting to provide visitors with the tools to think critically about the world around them? For science centers, this has been a philosophical journey: from looking at science as a body of knowledge to projecting science as a way of observing and understanding our world. Exhibits and programs based on the latter philosophy attempt to send the message to the visitor that they don't need to walk around collecting knowledge like so many bags of luggage. Instead, the message is that science can help visitors understand the world around them, and here are some of the ways in which to do this. Though a long-held maxim among museum people has been that "you can't fail museums," some people don't go to museums, because their educational experience has taught them that education and fun are mutually exclusive. They may fear a similar educational experience in a museum. Should museums try to change the educational stereotype that visitors may have experienced in school? Presenting the acquisition of knowledge skills as fun and accessible is a step in that direction. Plays from which visitors emerge commenting that "that was fun and I learned something too" seem not only appropriate but necessary.

The museum currently holds a place in the middle ground of social experience, somewhere between Disney World and the classroom. Museums are different than formal school. No one is required to go and no one is expected to pass or fail museums. They can be sensual and exciting, taking you down the elevator of a dark and grimy mine shaft. But after you take the ride the experience does not end, as it might in a theme park. Instead, it continues, revealing the life, work, and science in a coal mine. Museums can create that balance of fun and meaning making, moving beyond the Disney experience, but remaining independent of formal education.

A Brief History of Theatre

In A History of the Theatre, Wickham (1992) traces the meaning of both theatre and drama to "Greek words meaning respectively, a place in which to witness some form of action or spectacle; and a particular

27

kind of action or activity, game or play, so ordered and articulated as to possess a meaning for participants and spectators alike" (12). In other words, drama took place in a theatre. Today there is sometimes confusion as to the appropriateness of one word or the other. They are often used without strict differentiation, *theatre* encompassing the place as well as the action. It is primarily in educational theatre circles that drama and theatre are again separated and defined in the Greek sense. The term *museum theatre* has developed as an umbrella term encompassing both the practice and the place for myriad forms of drama. Thus, *theatre* and *drama* in this field have come to mean relatively the same thing, and I use the terms interchangeably. (Program titles incorporate both words, from the London Science Museum's Drama Programme to the Virginia Museum of Science's Carpenter Science Theatre.)

Over the course of its existence, the practice of drama was not restricted to a stationary theatre and has taken place around fires, on wagons, in giant open-air amphitheaters, inside or in front of churches, on platforms, within proscenium arches, in basements, and in the round. Theatre historians place the origins of drama to special sites set aside for the enactment of agrarian and fertility rites. These special places were various—a simple circle or an elaborate building or a hut—but each held meaning for the community (Barranger 1986, 29). Drama contributed additional meaning to these ceremonies. There is a visible parallel between these special places of meaning and modern museums.

Philosophically, the art of theatre has been thought to be a search for truth or an expression of the human psyche. Theatre's scope is as large as humankind's comprehension—perhaps beyond it. It is "essentially a social art enhancing and reflecting religious and political beliefs and moral and social concerns as well as literature, music, painting, and dance. Indeed, so wide are its terms of reference that theatre is often used as a metaphor for life itself" (Wickham 1992, 12). Theatre author Richard Courtney (1974) quotes Cicero (106-43 B.C.) describing drama as "a copy of life, a mirror of custom, a reflection of truth" (11). Today, Cicero's idea of truth might be actively debated, but the search remains the same.

Concurrent with ever-changing popular theatre movements and styles was the development of theatre in education. Beginning in the

Renaissance, humanistic concerns gave rise to education that would develop the whole man, skilled in many fields. Humanism emphasized the art of speaking, and much of this in dialogue, and it reintroduced the study of ancient texts. Focus on classical ideals led Humanists to emphasize that plays, or literature, have as their main functions "to teach and to please" (Brockett 1977, 160). This etched a place for drama in education. By the late sixteenth century, dramatic activities took place in almost every school. The French philosopher Montaigne believed that "the child shall not so much repeat as act his lesson" (Courtney, 16). At the convent of Saint-Cyr in France, girls improvised dialogue and conversation and performed plays by Racine and Corneille. "Associated with the school, Fenelon, Archbishop of Cambrai, wrote in his *Education of Girls* in 1687, 'Let them learn through play'" (Courtney, 17). In the twentieth century, this tradition of combining education and the practice of theatre developed into the Theatre-in-Education and Drama-in-Education movements, which I detail in Chapter 7. From its ritualistic roots, theatre has cultivated a long history of educating (Alsford and Parry 1991; Filisky 1989; Quinn 1993).

Today the discipline of educational drama, grounded in and yet distinct from popular theatre, is vast, growing, vital, and often contradictory. I believe one of the broadest and most helpful frameworks for educational drama is given by Robert J. Landy, in his book *Handbook of Educational Drama and Theatre*, who describes it as

> a field of inquiry that is inclusive and interdisciplinary, incorporating not only aesthetic but also pedagogical and therapeutic aims and techniques. (1982, 3)

It covers all the bases, without confining educational theatre. It allows for adult educational theatre as well as children, work with the disabled community, multicultural community uses, museum theatre, and more. Indeed educational theatre's reach is so expansive that essentially it is theatre without need for qualifiers.

Twentieth-century drama theorists such as Bertolt Brecht and Richard Schechner proposed changes to theatre's place in society. Brecht's theatre had social purpose and aesthetic form. His idea of Epic Theatre moved away from the middle-class or bourgeois theatre popular in the 1920s and '30s to a more radical image of social change

29

through didactic drama. He sought for the audience an experience of recognition and, as Brecht envisioned, consequent learning. Though audiences might respond with astonishment to a production, they also recognize it as pertinent to them (Shevtsova 1993, 140). Brecht's spectator is made to face something and the human being is the object of the inquiry (Brecht 1964, 37).[1]

Along with his study into the origins of performance/drama/ theatre,[2] Richard Schechner also cultivated a new form of drama called Environmental Theatre. Among the axioms Schechner developed were that "spectators were both 'scene-makers' and 'scene-watchers,' for, as in a street scene from daily life, those who watch are part of the total picture, even when they consider themselves to be mere spectators," and the event takes place in a found or transformed space (Brockett 1982, 704). This meant "abandoning traditional theatre architecture in favor of places already suitable as environments, or that may be easily converted" (Brockett 1982, 704).

Both Brecht and Schechner have had a profound effect on how people think about theatre. They moved theatre away from the complacent, observational quality of traditional theatre, breaking down barriers between the spectator and the actor. Their work informs museum theatre as well, where there are few conventional barriers between actor and visitor: actors often speak directly to audiences; there is no fourth-wall illusion; audiences are quite often inside the environment of the theatre piece in an exhibition; it is participatory in nature; and human activity is the object of most pieces.

In recent years, theatre has been coming back around to its roots in the community and education. Commercial theatre in the United States has become fairly isolated from the general populace for various reasons, among them expensive ticket prices. For the majority of people theatre remains inaccessible, while educational theatre programs continue to grow. While bringing theatre back to the community is only positive, the imbalance between what is considered commercial and what is considered educational is unsettling. The current political climate feeds this idea by obliging theatre to justify itself as educational and to downplay its aesthetic merit. Theatre practitioners must beware to make theatre that is important, challenging, and worth bringing to the public and educational communities.

Technology in film and television has opened people's entertainment choices, and these mediums offer more effective and immediate realism than does theatre. However, the element that theatre retains, which technology cannot replace, is a real, live person. Its sense of storytelling, fundamentally an oral tradition (Mello 1997), is its remaining uniqueness. Playwright Jon Lipsky (1994) believes that "theatre is really healthy in places where it serves the community, where people hear their own stories coming back to them."

Theatre and Museums Converge

The field of museums and the field of theatre meet at a point of convergence now because of their shared focus on education, in their mutual concern to connect with the public community, and in their collective search for truth in all its complexity. The origins and the goals of each field at times are parallel, at times intersect, and at times support one another. Their common facets outnumber their differences. For one, both museums and theatre by their natures are experienced live. This commonality should not be reduced by issues of technology and virtual reality. The dynamic of live experience is what visitors to a museum or a theatre seek, or they could stay home and watch television or surf the Internet. Consider this definition of ritual—"humanity's primary means of formalizing views about itself and the world" (Brockett 1982, 6)—and how this meaning corresponds with concepts of drama and museums. Like ritual, drama and museums stand as forms of education, which can be didactic and serve as a means of passing on traditions and knowledge. Conversely, drama has served as a medium within museums and ritual. Theatre was contextualized in ritual, part of a larger event, rather than the event itself, and it is the same in museums now. In this sense, theatre in a museum is no longer isolated. It has once again become a part of a life experience.

The emotional quality of theatre has often been thought inappropriate for a museum setting, but this separation is dissolving where the positive link between the two is realized. In a 1993 interview in *Museum News*, the director of the U. S. Holocaust Memorial Museum in Washington, DC, Jeshajahu Weinberg, discussed how his theatre experience has shaped his approach to museums. "Theatre is effective

31

if it triggers processes of identification in the audience, when it arouses empathy. I am trying to transpose the same principle of empathy to the museum. Theater is a place where your emotions get involved. The museum, usually not" (Strand 1993, 51).

Theatre is alive, relevant, and familiar, all qualities for which museums today aspire. This is a far cry from the intentions of those long-ago cabinets of curiosity or a museum dedicated purely to scholarship and collection. Its power is to allow us to view human interactions and make judgments about situations we may or may not have experienced, but that we can relate to and into which we can easily imagine ourselves. It touches on the collective human experience. It reaches behind humankind's accomplishments and progress in the arts and sciences to reveal the life force that created them. Similarly, Shakespeare wrote of theatre's aim: "to hold, as 'twere, the mirror up to nature." The goals and properties of theatre provide solid support for its use in museums, places where people go to explore themselves and their world.

Notes

1. Brecht notes the characteristics of both bourgeois or dramatic theatre and Epic theatre, charting his transition from one to the other.

2. For a fuller understanding of Schechner's research into the origins of theatre and performance theory, read *Essays on Performance Theory 1970-1976*, *Between Theatre and Anthropology*, and "From Ritual to Theatre and Back" in *Ritual, Play and Performance*.

4

Genesis and Impetus

Where has museum theatre come from and why? What are its foundations? What are the driving forces of museum theatre?

Theatre and museums have intersected and out of the convergence has come a new baby: museum theatre. Museum visitors all over the world are being surprised and drawn in by plays, gallery characters, and theatrical happenings. However, the use of drama and theatrical effects are not necessarily new to museums. Live interpretation and living history have been functions of museums on and off since that first experiment at Skansen (Anderson 1984). Certainly, dramatic showmanship had a place in P. T. Barnum's palace of oddities. Still, as in the history of museums, there is no straight line from Hazelius' theory of peopled exhibits to current museum theatre. For every move forward, there has been a sidestep or a step back. There are great differences between the objectives of live animation of exhibitions and scripted theatre within exhibitions. Respect for the art of theatre has grown up beside curatorial regard. Present-day museum theatre work has taken a big leap, and has moved beyond but off of the shoulders of live interpretation, living history, demonstration, and theatre-in-education. These four approaches have laid the foundation for museum theatre today. The initial three have evolved together in the museum world, so I will address them first.

Living history has been the most closely associated technique to modern museum theatre. Indeed, the umbrella term *museum theatre* includes living history. Historian Jay Anderson separates the field of living history into three groups based on their goals: those who are interested in using simulation of the past to interpret at living

museums and historic sites; those who use simulation as a research tool; and "history buffs" who undertake simulations for personal enjoyment (1984, 12). The first group addresses the realm of theatre most directly. These are the professionals working at Plimoth Plantation and Connor Prairie in the United States, Upper Canada Village in Ontario, and Oakwell Hall in England, among others. In these sites, the staff takes on authentic or fictional characters from a different era and interact with visitors in a re-created environment. In Oakwell Hall, they take a slightly different approach by having those playing characters interacting with each other, but not with visitors. The visitors may sit within the daily unfolding drama, but all questions must be directed to other designated staff wearing red T-shirts. Visitors are like the ghosts in Oakwell Hall, able to view life there, but unable to be seen themselves. This decision was based on trying to create the most realistic living history possible. There is no need for the interpreters here to know how to deal with such things as anachronisms, because they simply don't see them.

Among other like-minded organizations, the Association for Living Historical Farms and Agricultural Museums (ALHFAM) is a museum organization for those involved in living history, farms, agricultural museums, outdoor museums of history and folk life, and those museums—large and small—that use "living history" programming. ALHFAM's description of living history attempts to breathe life into static exhibits with staff working to re-create the work and life of the people who populated historic environs. Living history within ALHFAM combines the efforts of history museums, historical societies, and other educational organizations to truly engage the public with the impact of history on their lives today through the use of historic objects and environs and appropriate re-creations to tell the stories of the people who used those objects.

Living history techniques include first-person and third-person interpretation. In first-person, interpreters speak as if they are that character, which is very different than third-person interpretation, where the staff is perhaps dressed in costume, but does not take on a character. Third-person interpretation is often used to provide orientation or flavor to a site. It is also much less threatening for volunteers or docents to undertake, because they are free to answer visitors' questions

34

and do not have to act as anyone other than themselves. Recently, there was discussion on the museum-l and museum-ed, two electronic listserve groups for museum professionals, concerning the merits of first- versus third-person interpretation. Though a consensus can hardly be garnered from this exchange, the museum professionals who responded had deep concerns about the use of first-person interpretation: if undertaken, it must be done at the highest professional level possible, because half-hearted attempts will fail; and interpreters must know when to turn it off. It is perhaps most frustrating of all for a visitor to interact with a first-person interpreter who will not come out of character to address an anachronistic question or explain what he or she is doing. The interpreter is then in danger of losing the audience, and worse, having the opposite effect intended and making history impenetrable. On the other side of this debate, first-person interpretation done well can take visitors on a fulfilling emotional ride that will leave deep impressions in a way that a third-person usually cannot.

Plimoth Plantation currently employs staff to do both first- and third-person interpretation. At the settlement site, visitors can interact with the characters of those who settled the site in 1627. On a visit there a couple of years ago, a colleague of mine asked a man in several layers of thick clothing if he wasn't too hot for the extreme summer heat that day. The staff person responded, in character, that the clothing kept him safe from the sun and that he felt sorry for us with our exposed skin. My colleague responded good-naturedly that we have chemicals that protect us. This strange information did nothing to assuage his pity. At the Native American site, we sat in a wigwam with a man who was working on an arrow. He answered people's questions, but acknowledged the present day. He was not taking on a historic character. He was himself part Wampanoag and addressed both past and present issues. Both techniques were successful in creating an atmosphere of time travel and wonder in my mind. We had a wonderful day soaking up the verisimilitude.

Initially, living history focused on the re-creation of folk life based on historic documentation, but it has expanded to include all aspects of life. In 1994 a re-created Slave Auction, part of Colonial Williamsburg's Public Times Program, was an example of how far living history has come in re-creating historical reality, rather than a

select view of positive aspects, and not without controversy. Christy Matthews, director of Programs and Operations and formerly director of African American Interpretations and Presentations, described the staff at Colonial Williamsburg as confident that the time had come to deal with the most difficult image of American slavery. In previous decades, Colonial Williamsburg's approach of the African American perspective, though present, had been limited and not well known. Spectators critical of the event were concerned that it showed blacks as disempowered; that it would fuel racial discord; and generally, that it was inappropriate (Matthews 1996, 38-39). In the end, the auction was well received and one of the loudest critics was completely won over: "the presentation was passionate, moving, and educational" (39). Matthews details the major error made by Colonial Williamsburg as one of marketing the event. The marketing "did not show that complex history was a part of its offerings. Because of this, there were many who had no idea what to expect . . ." (39). As museums continue to redefine themselves, it is important to let the public know what that means.

One limitation to strict living history is the inability to comment upon itself to the public. Though there might be a lot of critical analysis going into the development of a living history program, which may serve to further understanding, it is difficult to share this with visitors when adhering to the precepts of the method. If a character can only relate events of a certain era, it limits the scope of visitor interaction. In the worst cases, visitors react with frustration when the interpreter responds with obtuseness, unwilling to drop character to assist their understanding. Third-person interpretation or other staff can help to offset difficulties in visitors' understanding by providing additional information and context. Second, visitors may take for certain something said or done within a site, when in fact there might exist subtle differences in interpretation concerning those same statements or actions. Often now living history will include elements of bigotry and intolerance based on historic documentation, assigning these attributes to certain characters. Done well, this can illuminate the full spectrum of real people who inhabited a site and a time in history. Done poorly, these actions and statements can have the opposite effect, upsetting visitors and producing serious consequences in our

current-day cultural climate. Living history is the re-creation of history and not the "real" thing, but it is often difficult for the visitor to separate the two. Authenticity is important to its integrity, but this same need can also be an impediment to full understanding, as when visitors mistake authenticity for reality. Historian Anderson details a European attitude termed *folklorismos,* or in America *fakelore,* to describe a fear that pseudotraditions will be passed on through live re-creation (Anderson 1984, 22). The charge that living history will cheapen a nation's (or region's) cultural heritage remains primarily a European one, going back all the way to Skansen's live animation. In this day and age, with the amount of scholarship and willingness to include the warts of history as well as the roses that most living history sites undertake, this prejudice seems like unwarranted conservatism. However, the ability to address interpretive debates with means beyond living history would directly answer critics.

It is here that museum theatre takes up the baton. Where the goals of living history are fairly straightforward, museum theatre can be more sophisticated. Theatre can move history forward, allow for current-day comment and insight, and explicitly connect its relevance to the modern day. A character can travel back and forth in time within a play easily. Using the modern context with the historical can add new layers of meaning. An example of how museum theatre does this is another Jon Lipsky script, *Unsinkable? Unthinkable!* The play tells the story of the *Titanic,* but brings in correlations between it and the *Challenger* disaster. The play moves from a historic recounting to an incisive examination of modern technological progress. There are no set conventions to hold the plot of a play back, beyond the knowledge that the experience is a play and not "reality." Many living history programs have expanded beyond their core first-person interpretations and now include plays. The different techniques work wonderfully together, serving the same goals and providing the visitor with the richest possible experience.

The progression from demonstration to theatre continues today. Many institutions are using theatre to enliven their demonstrations. Demonstrations of scientific concepts, historic craft making, live collections, and artisans have been presented in museums, historic sites, zoos, and aquaria for decades, and in the case of craft making,

nearly a century. The Museum of Science has a daily roster of at least six demonstrations per day, including the grand Theatre of Electricity where huge lightning flashes jump from the Van de Graaff generator. Other museum demonstrations are more intimate and may take place continuously, as it would for a wool spinner or a potter. The New England Aquarium has daily dives to feed the fish in the main tank, which are explained by a volunteer at the tank's rim. In demonstrations, the person demonstrating is generally not assuming to be anyone else or proceeding with a plot. Traditionally, the goal has been a straightforward explanation accompanied by showing something real, such as an animal or a spinning wheel. As Robert Finton of the Maryland Science Center put it: "Demonstrators excel at explaining the wonders of the workings of a leaf, whereas actors expose the beauty of the entire tree" (1992, 3). Both have their place. Many demonstrators have added to their presentations, weaving theatrical techniques such as storytelling and characterization into the fabric of demonstrations. Conversely, actors are honing their demonstration skills.

Robert Finton has been combining theatre into demonstration since 1988, using "characters" within his demonstrations. During a portion of his demonstration on special effects, he becomes one of his characters, Sheriff Bob. After demonstrating smoke, flame, and other visual spectacles in relationship to the chemistry and physics of special effects, he leads the audience to the realm of acting with special effects. He shows that for a special effect to be truly believable, the actor must act the part. At that point in the demonstration, Bob dons a cowboy costume and goes into the role of "a sheriff forcing the bad guys outta town." Following this, he demonstrates the effects of a blank-squib pistol. Bob reports that he can actually get the majority of the audience to perform an A-1 Bugs Bunny death scene with only one shot being fired. "It's a riot! The audience loves it and my staff and I get to ham it up" (Finton 1997). I have actually witnessed Bob's demonstration at a conference, where he gave the science museum staff audience brief directions on how to die dramatically when he fired his pistol. The entire room of 150 participants responded on his cue with elaborate spasms, pratfalls, and glazed eyes. It was, as Bob puts it, a riot!

On a newer project, Bob and his staff worked on an updated demonstration on optical illusions. They included some magic and a few small "magical gags" that involve some acting. Additionally, on special occasions Bob has presented some of the Science Center's standard demonstrations with the help of special "guest" authorities, such as Benjamin Franklin lecturing about lightning while using the Van de Graaff generator, and Nikola Tesla showing off his Tesla Coil. The Maryland Science Center hosted the Oregon Museum of Science and Industry's exhibition entitled Star Trek: Federation Science in the fall of 1997. For its run there, Bob and his staff did a demonstration as Starfleet officers in uniform and in character. Here the line between theatre and demonstration gets blurry, and it is safe to say there is a lot of crossover between the two. A theatrical demonstration can have characters, a narrative, and emotional engagement. Delivery style and ability can really make the difference, weighting a theatrical demonstration heavier one way or the other.

The story form has become a guiding force in the development of live animal demonstrations at the Museum of Science, Boston. Rather than listing facts about an animal, the educators are encouraged to build a story from the life of each animal. So that instead of beginning the demonstration with the attributes of an animal, the demonstrator might begin by telling the story of how this animal came to be at the Museum of Science.

Both living history and demonstration can be considered forms of interpretation as can the more encompassing term *museum theatre*. The tenets of interpretation relate directly. Each is striving to reach and engage the visitor, to move beyond static exhibitions, to convey meanings without resorting to a list of facts. In his groundbreaking 1957 book, *Interpreting Our Heritage*, Freeman Tilden mapped out six principles for interpretation (6).

I. Any interpretation that does not somehow relate what is being displayed or described to something within the personality or experience of the visitor will be sterile.

II. Information, as such, is not interpretation. Interpretation is revelation based upon information. But they are entirely different things. However, all interpretation includes information.

III. Interpretation is an art, which combines many arts, whether the materials presented are scientific, historical or architectural.
IV. The chief aim of interpretation is not instruction, but provocation.
V. Interpretation should aim to present a whole rather than a part and must address itself to the whole man rather than any phase.
VI. Interpretation addressed to children should not be a dilution of the presentation to adults, but should follow a fundamentally different approach.

Though Tilden wrote his tenets for interpreters at national historic sites and parks and did not have museum theatre as a model, they are useful in defining it. What is museum theatre if not something that presents the whole of an incident or discovery and not just a part? Furthermore, these points can assist in self-analysis and evaluation of the work. Is a project establishing common ground with visitors so they can relate to the story? These tenets provide a very firm foundation for theatre in museums. To begin with, in Tilden's first tenet he cautions that good interpretation must have within it something that the visitors can relate to their own life experience. In theatre, a play scene set forth showing humans interacting can establish common ground for the audience. Hopefully, the visitor will develop empathy for the characters or the situation of a play. Even without strict realism, as in the Museum of Science's play *Unsinkable? Unthinkable!* by Jon Lipsky, which has a crab narrator, visitors are riveted by the story of individuals aboard the *Titanic*. It is the power of myth, the establishment of shared human experience.

I believe one of the strongest and most important tenets in common is Tilden's fourth. Theatre must not become instruction. Its power is to provoke questions, a debate, an emotive response. In fact, the introduction of theatre into museum spaces that are traditionally unemotional implicitly sanctions provoked emotion. We are inviting visitors to share what they are feeling by addressing the human condition within the context of any discipline. In the Museum of Science play *No Easy Answers* by Marilyn Seven, two sisters turn in frustration with each other to the audience to ask what they would do in the situation of the scene concerning their father's treatment for Parkinson's

40

disease. This play was performed in an enclosed theatre space and not connected to an exhibition, which allowed for quiet contemplation and discussion. Visitors often brought their own experiences into the debate. Last, theatre is also an art that combines many arts. Music, puppetry, movement and dance, visual arts and design, poetry and literature all play a part to the whole experience of theatre.

The next step that modern museum theatre has taken beyond its foundations and what separates it from similar approaches, is its declaration that it is theatre. By this I mean that it is not borrowing theatrical techniques, it is not a theatrical demonstration, it *is* theatre, and as such, the need to maintain its integrity as well as the museum's must be recognized.

This testament has not been without its costs. Calling a museum program "theatre" has been difficult for many museum professionals to accept. There is a perceived threat that the integrity of theatre might overwhelm the integrity of the museum. It is also tied to the fear of "fakelore" and misinterpretation. Consequently, the development of museum theatre over the last several decades around the world has been difficult, isolated, and highly individual. How was the jump made from its foundations to its present form? Could it be, as Alford and Parry (8) have suggested, that simply putting staff or volunteers in period costumes brought with it a sense of theatricality and the tendency to speak in first person, leading to formal role playing? Perhaps that is so, but I believe the use of theatre in museums did not arrive or maintain itself so ingenuously in most institutions. In many cases, it was effectively subversive.

Sondra Quinn, now director and CEO of the Orlando Science Center, began her museum career at the Science Museum of Minnesota. She had studied theatre, but was encouraged to pursue a more stable career and found herself in the Science Museum. In 1971, called upon to provide security for an exhibition, Quinn instead used the funds to create a theatrical piece that would serve to guard the exhibit and entertain at the same time (AAM 1996). To the surprise of the staff, it worked, and that was only the beginning. Quinn converted this success into a full-scale theatre program. In 1996, the Science Museum of Minnesota celebrated its twenty-fifth year of using museum theatre.

The Museum of Science in Boston began incorporating theatre into its live programming in 1985. The program has continued to expand, though not without setbacks. In 1991 the Science Theatre Program survived a major financial crisis by functioning essentially without direction from the administration. David Ellis, newly appointed director of the museum, was given the task of putting the museum's house in order. Among the positions eliminated was the stage manager, which was a position that had full-time benefits. Luckily, because the actors were considered temporary part-time employees of the museum, we were not laid off.

We had actors, but no money for plays. This technicality did not stop us. The natural tenacity of theatre people and one dedicated physicist kicked in. Following the layoffs, another actor, Mark Waldstein, and I worked with Mike Alexander on our own to create a new solo piece to accompany an exhibition called Gems. With previously used props and costumes and working only for our hourly wage (with money in the general Education budget), the three of us wrote a ten-minute piece, *The Secret of Diamonds*, about the history of diamonds from alchemy to atomic and molecular understanding through the story of the Hope Diamond.

We worked in a corner of the exhibition without a sound system or stage. We used a boom box for music. The audience sat either on the floor or on two benches. The play was very simple, told through the character of Jean-Baptiste Tavernier, a Parisian who discovered the Hope Diamond. Mark and I alternated playing Tavernier, with a wink to the audience and a very bad French accent. This play proved very successful with audiences, and worked well within the context of the exhibition.

> Bravo to [the actor] and her "Tavernier" performance in the Gems Exhibit! What a delightful "change of pace" moment with the show [exhibit]—and engages the little ones so wonderfully–fun and very informative. (Visitor Comment Card 1991)

Surrounded by cases of beautiful cut gems, the play added the necessary human element. Showing its merit to the administration, the Science Theatre Program was able to begin quietly rebuilding. While the administration did not immediately increase its financial support,

it did not seek to disband it either. John Shane, Vice President of Education at that time, helped a great deal by supporting the idea of science theatre to upper management.

There have been fits and starts to many museums' programs, but with luck, this rocky road has only made museum theatre stronger by pushing those doing this work to find innovative solutions to roadblocks such as funding or support. Unfortunately, in today's economic climate, museums are facing difficult decisions, and very often it is live programming that continues to be the most vulnerable. Subversive means continue to be necessary. In fact, most theatre people pride themselves on going against the odds and do not find the difficulties facing museum theatre any different than those in the greater theatre world.

There were signs of progress in 1978 when the Association of Science-Technology Centers sponsored the workshop A Stage for Science: Dramatic Techniques at Science-Technology Centers, with representatives from seventeen different institutions attending (Grinell 1979). Fifteen years later, the 1993 Why Go Live? Conference and Festival in Bradford, England, was attended by more than 100 museum theatre practitioners from the United Kingdom, Netherlands, France, Canada, South Africa, and the United States. Hosted by the National Museum of Science and Industry's Museum of Photography, Film, and Television, this meeting showcased different styles of museum theatre from various institutions and opened the way for a more critical dialogue concerning issues in the field. Principles were laid out by various participants:

authenticity
credibility
accuracy
research
communication
recruitment
training and support

These issues, such as who should be recruited to perform museum theatre—actors, staff, historic interpreters—sparked lively discussion. The following year, the Languages of Live Interpretation Symposium at the Canadian Museum of Civilization in Ottawa continued the

discussions begun in Bradford and again showed top-notch examples of museum theatre. The proceedings have been collected in a publication called *The Languages of Live Interpretation* (1997), dedicated to the late David Parry, a pioneer in the museum theatre field who organized this meeting.

On my return from London in 1990, I organized the International Museum Theatre Alliance (IMTAL), supported by, among others, the Museum of Science and initial members Pippa Richardson, Marilyn Seven, and David Parry. More consistent methods of communication had become necessary as programs developed in various institutions, and the Alliance was founded to serve that need. In 1994, IMTAL was approved by the American Association of Museums (AAM) as an Affiliate organization and is now represented on the AAM Board's Council of Affiliates.

During all these years, a constant has been the Science Museum of Minnesota's (SMM) annual workshop on theatre in museums. Since 1985, the SMM has offered its workshop to give other museums an opportunity to observe its theatre program and see how it might be adapted to other institutions (Bridal 1990). In 1992, Tessa Bridal of the Science Museum of Minnesota and others formed an American Association of Museums' Professional Interest Council on museum theatre (MTPIC) to further increase communication. Through IMTAL and now the MTPIC, the concentrated, organized modern museum theatre movement has really begun.

Increased communication within the entire museum community has in turn allowed singular museum theatre successes to inspire others. The Science Museum of Minnesota, Museum of Science, and a few other institutions have been leaders in the field. Several plays developed by the Franklin Institute in Philadelphia have toured with exhibitions and been performed by different museums. The Museum of Science play about rocket scientist Robert Goddard, *At Seventeen I Climbed a Cherry Tree,* by Marilyn Seven, was produced at the Franklin Institute. The Pittsburgh Children's Museum produced the Science Museum of Minnesota's *Sara the Scientist.* Hence, the domino effect is a logical hypothesis as to how museum theatre has evolved. However, while acknowledging the effects of one museum's program on another on down the line, I believe that the theoretical and practical changes

44

in museums and theatre previously detailed, in addition to education and learning theory, have come together to create a breeding ground for the idea that theatre is an appropriate and effective educational tool for museums. And it is in consequence of these changes that museum professionals around the world have come to the same conclusion spontaneously, and mostly on their own.

As an example of that isolation, in 1988, when I knew I would be attending the London Academy of Music and Dramatic Arts, I wrote to the London Science Museum with an offer to portray Ada Lovelace. I was aware of the Science Museum of Minnesota and perhaps a few other smaller museum theatre efforts. In my letter to London, I explained theatre in the Boston museum and supplied arguments for its use. Pippa Richardson, then in charge of the Drama Programme in London, replied that she would be most interested in the character of Ada, which might fit very well into their already flourishing drama project. My ignorance of what was out there was clear, and Pippa was pleasantly surprised to hear of the Boston program.

The Development of the Museum of Science's Theatre Program

At the Museum of Science, the use of theatre grew out of a need to go beyond the successes of live demonstration. The museum has a long history of live public programming. In the early 1980s the education staff wanted to pursue a more narrative, emotional path, because they were interested in concepts such as women in science or the death of dinosaurs, which would be difficult to demonstrate. Additionally, lectures would not enliven the subjects with the inspirational quality they sought to create. It was a natural progression to decide to use theatre.

At this writing, there are nine part-time actors and a coordinator position on the Science Theatre Program staff, supervised by the manager of Science Theater and Public Demonstrations, Michael Alexander. The program has been formed by his efforts and vision.

A physicist by training, Mr. Alexander is part of the museum's Program Division (formerly the Education Department). Alexander has had a part in creating the comprehensive and innovative roster of

demonstrations in the exhibit halls. The museum has had stages designated for Physical Science, Lightning, and Live Animal demonstrations, as well as two multipurpose theatres that have presented several additional scientific demonstrations since the 1950s. There is now a new stage in the museum's Investigate exhibition, where shorter, more open-ended presentations take place daily. The museum's traditional demonstration is up to twenty-five minutes long and reveals how something works within that time frame. Investigate "Challenges," as these particular presentations are called, invite the visitor to figure something out themselves, rather than providing the answer. Demonstrations and Challenges touch on most aspects of the sciences, physics in Super Cold Science, and biology in animal demonstrations, as well as their application, such as computer technology in The Science of Special Effects. As noted, this strong history of doing live demonstrations contributed to the birth of the Science Theatre Program, but the decision to use theatre goes to deeper issues about museums' functions. Alexander frames the progression as a "generational shift, when you change your paradigm for what it means to do programming in the museum, or what it means to be a museum" (Alexander 1994). With no theatrical background or training, Alexander came to realize that there were certain scientific subjects that might best be explored and presented in a more dramatic form. "We started to realize there were lots of subjects we couldn't approach adequately with regular demonstrations, such as current science at that time, like the continental drift. We wondered whether it was possible to do dramatic presentations" (Alexander 1994). At the same time, the museum's education staff had been presenting amateur Halloween shows with chemical reactions and displays of electricity for community groups, and as they became more elaborate, Alexander reports, "we realized that in order to be successful we were going to need to add theatrical values, like good acting."

Initial efforts toward this end involved museum education staff. "We were OK at that, but none of us were trained actors." At this point in discussions, the staff was concerned that actors wouldn't have the educational abilities necessary for this work. However, the success of the Halloween shows opened the door to more dramatic ventures. While proposing this idea to his superiors, Alexander serendipitously

received an invitation from the Science Museum of Minnesota to attend its theatre in museums workshop.

After returning from the workshop, where he met the late playwright Marilyn Seven, he decided to create a dramatic piece for school groups before they went into the blockbuster exhibition, China. It had become apparent that previous groups were not understanding certain aspects of the exhibition. There were many artifacts with labels about their use, but student groups were not connecting the ideas. Alexander, with others in the Education Department, chose to focus the play on five or six artifacts that connected to the important science of the time, all of which the schoolchildren were going to see in the exhibition. The scheme of the resulting play, *Dragon Bones*, centered on a dragon who has the ability to take any form it chooses, coming to earth as a person and encountering a Taoist monk. The dialogue focused on the artifacts. It was performed by museum educators who did not try to become the characters, but instead dressed in shirts with the China logo, defining them as exhibition staff. They were not attempting to be actors, but to do a more theatrical presentation than they had in previous demonstrations. It was successful as such. *Grave Doubts*, a similarly styled presentation, followed. The success of these programs led up to the *Mary Rose*, an exhibition on King Henry VIII's ship of the same name. Thus far resisting the label of theatre, they realized they had been doing it already without calling it theatre and were now ready to proceed officially under that designation.

The *Mary Rose* exhibition had a lot of human interest aspects to it that were not evident in the exhibit itself, as well as a number of artifacts. Alexander, a technical museum staff person, and the Exhibit Planner decided together to hire a single actor to do a play in the exhibition. The museum technician had a theatre background and, with Alexander's input and an MIT student's commissioned software, developed the first computerized remote-controlled lighting and sound system for this play. This system, recently upgraded with a new independently developed digital program, has allowed the Science Theatre Program to incorporate extensive lighting and sound effects in its productions.

Playwright Marilyn Seven was hired and wrote *The Barber-Surgeon Had a Wife*. The play was based on the ship's barber-surgeon, whose

sea chest of artifacts was salvaged along with the *Mary Rose*. The play was presented on a small stage that replicated the barber-surgeon's cabin. It was presented three times a day on weekends and every day of school vacation week. An outside evaluation determined that the play was successful in bringing visitors into the exhibit area, captivating their attention, and providing an opportunity for visitors to ask detailed questions about the exhibit (Hein, Lagarde, Price 1986).

Many elements fell into place to pave the road to doing theatre at the Museum of Science. Alexander credits the Minnesota Science Museum's workshop with showing him, among other things, how theatre breaks down stereotypes. This became an underlying goal of the program. Subtle or overt, theatre can change perceptions without stodgy didacticism. This subtext has shaped many of the Museum of Science plays. In *Einstein's Little Finger*, the female character takes a protechnology stance, opposing the back-to-nature attitude of the male character. *The Bones Wars* is a play about a feud between two early paleontologists; its Old West character warns the audience that "Science just ain't pretty."

In 1987, Alexander hired a theatre director to create a vignette describing the technology of the Omni Theater. Actors were selected through auditions, advertised in the arts section of Boston's alternative newspaper. The director decided which actors to hire with Alexander's approval. In the vignette, two actors performed several times each evening as an introduction to the Omni movie, one comically pantomiming what the other said. As popular entertainment the seven-minute vignette was thought a success from positive visitor reaction, though no evaluation was done to measure its educational value.

The opportunity to explore more fully the potential of theatre to interpret an exhibition came with the traveling exhibition Women in Science. Alexander believed that theatre was the most appropriate tool to use in augmenting this exhibition. How can you demonstrate the hurdles women in science overcame? How can a scientific institution show the human face of scientific achievement? How might you do both at the same time? He discovered the story of the life and work of nineteenth-century mathematician Ada Byron King, countess of Lovelace, which was readily translatable to the stage. *Ada: The Bride of Science* premiered in 1987.

The program has continued to expand, though as I have pointed out, not without setbacks. Slowly building on successes, the work continues to mount, sometimes seeming like a cartoon snowball, getting bigger and bigger as it rolls down a mountain. More often, requests are now coming in from other departments of the museum for the Science Theater Program staff's unique talents. Never satisfied with repeating past successes, Michael Alexander continues to take chances and push the program to new forms and stylistic heights. In 1993, the Science Theatre Program staff opened four new plays, reworked several others, and participated in several national and international conferences on museum theatre. In 1997, Science Theater opened a new play, *The Masque of Leonardo*, in the traveling exhibition Leonardo da Vinci: Scientist, Inventor, Artist. Jon Lipsky's clever script and bold direction created a spectacle of images and ideas based on da Vinci's notebooks. Rather than approach the story of da Vinci's last days and his legacy using a traditional historical narrative, Lipsky attempted to place the audience inside the complex and contradictory mind of the great man to show us how Leonardo saw. Preliminary results from a visitor survey show an overwhelmingly positive response from visitors who saw the play. When asked if they felt the play added value to their exhibition experience, 95 percent of those surveyed responded in four ways: generally positive; those who related the play to themselves; those who related the play to the exhibition; and those who related the play to Leonardo the man (Adolphe, Baum, Hughes 1997).

Museum theatre's success at reaching visitors, creating innovative experiences, and furthering the mission of museums, zoos, aquaria, and historic sites is its impetus. Success spurs us on. The foundations of museum theatre provide it with steady footing, so that museum theatre can carry Hazelius' torch and shine light on the idea that without people a museum is a dry shell.

5

Goals and Principles

What is the pedagogy behind museum theatre? Is the goal of museum theatre to teach? If so, what does it seek to teach? How do visitors learn from it? What principles are guiding its use?

In his book *On Knowing: Essays for the Left Hand*, Jerome Bruner (1965) describes something he calls "effective surprise" as the hallmark of creative enterprise:

> It is the unexpected that strikes one with wonder or astonishment . . . effective surprises . . . seem to have the quality of obviousness about them when they occur, producing a shock of recognition following which there is no longer astonishment. (18)

He goes on to separate effective surprise into three categories, the last being metaphoric effectiveness: "it is effective by connecting domains of experience that were before apart." I equate Bruner's surprises with the "a-ha" moment that museum educators and exhibitors talk about, and it is precisely what we seek to do with museum theatre: to effectively surprise visitors by presenting a new or different way of looking at a museum's content and discipline.

The goals of museum theatre go beyond the basic "to bring exhibits to life"; it is a powerful tool to communicate complex ideas and to create convincing real experiences for visitors. In today's museum culture, there are immediate, pragmatic goals for museum theatre, among them: to provide a value-added experience; to enhance education within an exhibition; and to bring in new audiences. These are important, but beyond them lie deeper, more fundamental goals for the use of theatre in a museum: to captivate; to be reflective and topical; to motivate and provoke.

It is difficult to separate the goals of museum theatre from the goals of museums themselves. It is a symbiotic relationship. Theatre is the vehicle with which museums may achieve their goals, but at the same time, theatre also expands the possible goals that museums may propose. For example, certain controversial subjects might seem unapproachable if not for theatre's ability to present a prism of differing perspectives through various characters in subtle, nonthreatening ways. Advances in technology have brought about positive and negative outcomes, but museums have traditionally displayed evidence only of the former. However, in a play called *Einstein's Little Finger*, by Marilyn Seven, the Museum of Science expanded its own goals to include helping visitors to think critically about how society proceeds through science by presenting a young couple in the throes of wedding planning that turns into an animated debate over technology. Additionally, many zoos and aquaria are wrestling with the topical mandate to motivate their visitors about conservation. The message is a difficult one to get across without sounding preachy or patronizing. In their search for an imaginative, agreeable mechanism, many have turned to theatre.

Essentially, museum theatre has no goals apart from those of the institution within which it takes place and its own dictate to be good theatre. Of course, that raises the thorny question: What is good theatre? To begin with, the basis for drama is conflict, which can reveal itself through a character's inner turmoil as well as through a confrontation of differing points of view. Without conflict, there is no drama. This is an oft-ignored principle, which leaves museum theatre pieces struggling to maintain direction. Conflict is the rudder that steers the theatrical boat. Additionally, there is an ethereal quality to good theatre that produces moments of epiphany and transformation that are difficult to explain by creator or viewer. All the elements—acting, writing, directing—and the audience come together in a particular instant. It is the art of theatre.

In museums, I believe this means that theatre can move beyond the pleasant experience and metamorphose into what educator John Dewey would call an educative experience that leads to positive continued growth. Museum theatre is not educative in an isolated sense. Dewey's educative principles place museum theatre on a continuum of

connected experience that is influenced by earlier ones and, in turn, influences the next. If a museum theatre piece is disconnected from this continuum, even if pleasing, it will lose its effectiveness and become miseducative. "Continuity and interaction in their active union with each other provide the measure of the educative significance and value of an experience" (Dewey 1938, 44-45).

Museum theatre uses its expansive power to achieve many goals—such as revealing for the visitor the relevance of any given subject, whether it be genetics, therapeutic art, or the settlement of communities, and surprising the visitor into looking at domains of information in new ways.

Putting aside debates about the definitions and merits of cognitive (factual knowledge) and affective (emotional understanding) goals, an advantageous aspect of theatre is its ability to mix the two and encourage responses in both. Showing the human endeavor behind the creation of a piece of art in a theatre piece can address the emotional struggle as well as the technique employed. In the Museum of Science play *The Ballad of Chico Mendes*, by Jon Lipsky, a goal was to showcase Mendes' efforts in the rain forest, such as his idea of Extractive Reserves. Within the story of his life and eventual assassination, there were many opportunities to engage visitors emotionally. At one point, the audience was asked to join the two actors in standing up to the cattle ranchers, who were threatening the rubber tappers. This scene was a re-creation of an actual incident, with everyone shouting "Viva Amazonia!" The rubber tappers won in this case, though Mendes was later killed by one of the cattle ranchers.

Engaging visitors' emotions at this level is not without its detractors. I have heard several educators express alarm at such emotional stimulation. In a roundtable discussion on museum theatre at the Council of Maritime Museums' 1997 conference, the optimum level of emotional engagement became a major focus. There was concern that visitors were not seeking such emotional fare, which was countered with the idea that to limit ourselves to what visitors expect is to diminish the potential experience. There also exists fear that the visitors' emotional state will cut off cognition. I believe that the opposite is true, that emotion sparks cognition.[1] This is one of museum theatre's most powerful attributes, which in turn allows for most goals: it

draws visitors in with its emotional content. It is analogous to Jon Lipsky's idea that if you don't succeed in moving people with museum theatre, they haven't been engaged at all (Lipsky 1994). In his book on the history of theatre, Wickham states that "drama calls upon our minds and hearts to respond simultaneously, the one in step with the other" (1992, 12). The mind comprehends while the heart is engaged, and vice versa. One without the other diminishes the play experience to an academic lecture or a soap opera.

"The immediacy of theatre—its ability to seize the visitors' attention—makes it a powerful agent for motivating and empowering people to learn" (Filisky 1989, 10). There is a transformational process to theatre, which begins by engagement and is propelled by Bruner's metaphoric surprise. The visitor experiences the a-ha moment, the integration of different ideas, which then transforms into meaning, translating lastly into language and action. We cannot know anything without the initial engagement.

From the Universal to the Particular

My personal goals are guided by the Museum of Science's goals, which are in turn guided by the larger museum community's collective goals at this time in history. Our worldview shapes all of the above. Each level is also equally important. If the actor has no interest in the goals of the museum in which he or she is working, that will have an impact on what goals are achieved. It is, therefore, meaningful for those working in the field to articulate their own objectives and sense of the work.

Because our worldview shapes our goals, I begin by declaring myself, as others in the field might, a Humanist seeking to integrate seemingly disparate disciplines, balancing science with the arts and humanities. Balance is crucial. I am trying to achieve educational goals, while maintaining the integrity of theatre as an art form. I approach my acting work in these plays in the same way as I would a role in a traditional theatre. I build a character that I hope will prove believable and approachable. In character, I seek empathy from the audience, an emotional, mental and physical response. I attempt this through my own talents as well as through theatrical elements such as lights, sound, costume, language, and objects. I believe that knowledge is

personal and not fixed. Hence, I try to create an atmosphere of magic that allows the audience to collectively and privately shape the experience.

An obvious and therefore often unstated principle of this work is that it is live and consequently dynamic. This creates the potential for modification, variation, and sharing. The performer shares with the audience, but the audience transmits messages as well. It is not a one-way street. The tone, mood, and rhythm of each show reflect the audience's participation. This dynamic also allows access to a wider range of visitors, each performance varying to reach that particular audience as a whole, and the individual visitors who comprise it.

By performing in character, I am seeking to change the reality of that moment. The elements of time and space shift. A woman remarked to me after a recent show, "I felt like I was there." However, I am not attempting to fool anyone into thinking I am anything other than an actor in a play. That is the reality. It is within the performance that I am seeking to change time and space, without any hypocrisy concerning what is real. I seek not to imitate reality, but to create a new one. In his introduction to *New Directions in Theatre*, Julian Hilton proposes that this is possible "because of the overall context of relativity in which space, time, and identity itself are dynamic, not static, in nature" (1993, 7).

As Larry Coen (1994), a fellow museum theatre practitioner in Boston, describes it, we are making a contract with the audience. This is important, as it implies agreement. I cannot force a reality change on the audience. Rather, I must invite the audience into it by giving them structure or the guidelines of the contract. Visitors have a description of the play on their program of events, on the play's sign, with the announcements over the public address system, and from me. If visitors have questions as I set up the show, I answer them. I continue to guide people as they sit down, and the beginning of the plays often give many clues about what will follow. Most often, the lighting and sound effects assist by putting the audience in a dark space, opening their senses, and focusing their energy. Their agreement with me as I perform creates the performance.

I strive for a level of professional ability in myself as an actor. I have found that the quality of my work directly influences the response

from the audience. They want a good performance that will entertain them. Many visitors are wary until assured of their possible enjoyment of the play. They don't want to risk participating in an embarrassing situation. The assurance comes from a detectable confidence and professionalism from the performer. I am a proponent of using actors for this reason, but I also know that nonactors can be found with these qualities. Also, if I am having fun in my performance, visitors are further assured that they can have fun too.

Though I endeavor to make people comfortable through the performance, occasionally it takes more work than I normally anticipate. During a performance of *The Bog Man's Daughter*, four boys around thirteen years old, who had been told to sit down and be quiet by their chaperone, could not stop themselves from heckling quietly under their breath. I could hear them, but they were not loud enough to bother others in the audience. I ignored their comments and picked one of the boys to assist me in building a *foote* with peat blocks, and eventually they quieted somewhat. After the play, they stood up, grumbling remarks. I walked up and put my arm around the tallest boy's shoulders and said amicably, "You know you guys, I am a live person, and I could hear everything you said." One of the other boys blurted incredulously, "Well, aren't you embarrassed?!," which to me meant "to be standing in front of people, talking and singing?" I replied, "No, I'm not embarrassed, I love what I do. It's you who are embarrassed, because you don't know how to act when you watch a play. You were so aware of yourselves. You couldn't leave yourself and just enjoy the performance like other audience members." With my arm still on the boy's shoulder, we discussed it for a few minutes and they left. We are in the computer age, which makes the live experience that much more a novelty and this job that much more important and challenging. I have no idea whether I was able to reach them or even influence their behavior the next time they see a performance, but I hope so. They may see me again in another incarnation.

Museum of Science Theatre Goals

At the Museum of Science, Boston, the Science Theatre Program is seen as an educational tool that can address multiple goals. It is

accepted as a way of conveying information and ideas that an exhibition does not or cannot, of changing attitudes and provoking questions, and of creating memorable and stimulating experiences for the visitor. All of this contributes to the main goal of furthering the mission of the museum.

Science Theatre plays are attempts to layer the cognitive with the affective. Any given play might have several different educational goals. *Einstein's Little Finger* was developed to teach visitors about advances in technology as well as trying to provoke visitors into articulating their own ideas about the pros and cons of these advances. Visitor comment cards revealed it to be a "thought-provoking and challenging experience" and a "novel approach to learning." A cognitive goal within *The Secret of Diamonds* was to teach visitors the molecular difference between graphite and diamonds. The actor used two audience volunteers to physicalize the electrons and atoms of graphite, and then, by changing the connection of their arms as the electrons, turned them into diamonds. Furthermore, because many of the Museum of Science plays are written for public audiences of all ages, different information reaches different audience members and interpretation can be personal. There need not be a yardstick for whether the audience "got" the educational message. The five-year-old and the eighty-five-year-old can each walk away with something, common or unique, from the play experience.

Science Theatre can also have more than one meaning. Though on the surface a play might have the goal of teaching about one subject, there can be more subliminal ancillary objectives. For example, as Michael Alexander realized from the Science Museum of Minnesota's workshop, theatre can break down stereotypes. The scientist as woman, or black woman, is easy to establish. Admittedly, that can be done in a demonstration. But would a demonstrator of color want to address the issue by revealing his or her personal stories of discrimination? Good theatre can be far more subtle and reveal many layers, depending upon the visitor's personal interpretation. Additionally, visitors need not understand every layer to appreciate the play.

To illustrate, the Museum of Science's reworked play on Ada Lovelace, *Byron's Childe*, depicts a woman mathematician working in the male-dominated nineteenth-century scientific world. Lovelace's

work to develop a program for Charles Babbage's mechanical Analytical Engine, predecessor to the first computer, sketches the history of computer science. The theatrical ability to go back in time to Ada's childhood experiments with flying illustrates the thinking of a curious mind. Her constant search for meaning and understanding of the world through mathematics shows math to be exciting and useful. Lovelace's determination to ignore the patriarchal restrictions around her serves to inspire young girls. Finally, though more meanings can still be found, Ada's dreamlike musings to her dead father, the poet Lord Byron, connect the worlds of science and art.

There has been quite a bit of discussion in the Museum of Science concerning exactly what we are attempting to teach with our plays. How can we approach the social and ethical implications of the Human Genome Project without first teaching what a gene is? Some visitors might know, of course, and others might feel it isn't important, while others might want to know more and seek to find that information. I believe if we attempt to teach such things as the definition of a gene before we can move on to more complex issues, we are missing the boat. This medium is the alternative to such defined goals of teaching visitors "the facts." We might be able, if successful, to motivate visitors to seek out the facts themselves, and that is more to the point.

There are, naturally, facts and ideas imbedded in most museum theatre pieces. But are they meaningful or simply justification for the piece? Facts imbedded in a strong narrative, subtly placed, compelling the action, are legitimate and can pave the road to a successful museum theatre experience.

From the Particular Back to the Universal

One fairly consistent goal among museum theatre programs is to connect to the educational mission of the institution. Within this, the educational objectives are varied and often unique. Goals can be drawn with a wide paintbrush, as at the Science Museum of Minnesota. In their article, "Science Theatre: An Effective Interpretive Technique in Museums," Sondra Quinn and Jacalyn Bedworth explain the SMM's approach: "Our goal, rooted in our phi-

losophy of providing a participatory experience, is to transform all the museum into a 'stage' where visitors can take an active role in creating their own experience" (Bedworth and Quinn 1993, 9). Furthermore, they detail how this program has gone about achieving the goal of influencing public perceptions of the scientific process or attitudes towards science and scientists.

Other museums develop goals for their theatre programs based on very specific institutional needs. The Pittsburgh Children's Museum's theatre program is primarily outreach, instead of inside the museum. Its exhibition space is limited, and shows are therefore developed with a connection to the institutional mission rather than to a specific exhibition and performed in schools and libraries. The Natural History Museum in London has engaged theatre and dance companies to enliven the museum and to change the conservative image held by its public. The Public Programmes section was given the brief "to create events for the public, which encourage new audiences and return visitors" (Mitchell-Innes 1997, 1). A Natural History Circus was staged under a big-top tent on the museum's front lawn in the summer of 1996, creating a dramatic atmosphere of anticipation and surprise.

Many times a goal is tied directly to the needs of an exhibition. The Franklin Institute in Philadelphia developed a play with Point Breeze Performing Arts Center called A Friend from High School with the traveling exhibition What About AIDS? The strategy of this forty-five-minute, four-character play was to "give its teenage audiences a strong personal stake in assimilating the facts presented by the exhibit. . . . Above all, it had to impart a functional understanding supplementary to the exhibit that's genuinely useful to its audience in making life decisions" (Bishop and Fuller 1993). A Museum of Science play, Two of Every Sort by Jon Lipsky, that deals with difficult subjects—gender roles, sexual behavior, and reproduction—took a more light-hearted approach by setting up a different goal: to examine sex from outside the human race, through the eyes of friendly extraterrestrials. Though very different in outcomes, these plays' goals were both laid out based on the needs of the exhibition to which they were a part.

All these discussions are hopefully invisible to the visiting public. Instead, they can find themselves enjoying the learning process, in

ways they might not have considered. I have often had visitors remark that a play was fun, but they were surprised to have learned so much. A lecture on the characteristics of Renaissance art might be intimidating or remote to some, but in a play with two young Italian lovers arguing its merits, as happened in the Baltimore, Maryland, Walters Art Gallery's play *Of Courts and Courtships: Scenes from the Renaissance*, it becomes an exciting game. This play took place in the Walters' gallery of Renaissance and Mannerist art, with four characters interacting alongside the collection while the audience followed the action as assumed banquet guests. The central romance in the play was suggested by *cassone*, or paintings made for marriage chests, in the Walters' Renaissance collections (Stillman 1992, 390). As Diane Brandt Stillman, Director of Education at the Walters, reported in a session at the 1992 American Association of Museums conference, 88 percent of the visitors surveyed who saw the play felt they learned a lot or quite a bit about the Renaissance. Comments made by visitors illuminated the statistics: "This is a more pleasing manner in which to experience the meaning of the paintings" and "I . . . prefer experiential learning activities . . ." (391).

Notes

1. Neurobiological studies have been looking into the connection between emotion and memory. Scientific studies showed that "emotional experiences could help cement memories into the brain" (*Chicago Tribune*, "Unforgettable Emotions," 20 February 1997, p. 7). Museums attempt to create memorable experiences, and there is certain criteria being developed that may guide museums in doing so. Scientists have been exploring ways of improving memory, and suggest that it is the context of an event that helps to retrieve details and, further, that strong emotions like love and hate associated with the context make this even easier. (See *New Scientist*, 11 March 1995, p. 44, and *Nature*, 6 February 1997, p. 481.)

6

Threads and Styles

This chapter details the many different styles of museum theatre, from improvisation to scripts to puppetry and storytelling. This is a look at the pros and cons for the use of any particular style with a number of different examples.

The comparison of and the decision on which styles of museum theatre to use should be based on the needs and resources of individual institutions. Judgments based on style are irrelevant. There are no rules about style, and I do not adhere to one approach.

In his work for the Museum of Science, playwright Jon Lipsky mixes styles, altering the mood and tone in a twenty-minute play by interchanging songs, moments of tragedy and comedy, farce or puppetry, every three to four minutes. He takes the visitor on a stylistic ride. That is, in effect, Lipsky's style of museum theatre, but not necessarily *the* style. Museums are unique places, and that uniqueness demands variations in stylistic factors.

Improvisation requires no script, though outlines for an idea might be used to shape a piece. It is the spontaneous, creative interaction with visitors that follows rules of play natural to human development. Children are unconstrained and accustomed improvisers. The *American Heritage Dictionary* defines the act of improvising as "to invent, compose, or recite without preparation" (909). The big difference between that definition and what goes on in museum improvisation is preparation. Though exact exchanges with visitors might not be fixed, there is a lot of preparation required for improvisation. The improviser must have a firm footing in the character and/or the sub-

ject at hand and understand clear lines of appropriate discussion. The parameters of exchange must be rehearsed and set out beforehand.

Museum theatre can be scripted, improvisational, or contain both styles. One is not necessarily better than the other. Improvisation allows for a wide range of information to be touched upon, most often determined by the audience's interest. Likewise, it is possible that only a small amount of information will be brought up, but explored in depth. Improvisation allows for more frequent and casual exchanges than a scripted play, though a script can ensure that specific information is covered. A script can also provide a clear traditional dramatic structure with a beginning, middle, and end, which can be very satisfying to an audience. On the other hand, an improvisation may be structured in the same way. Considerations for why a museum might use one rather than the other are often based on educational objectives and funding, as well as the facilities available and the abilities of the actors or other staff.

Gallery characters who interact with visitors on a one-to-one basis, as they do at The Science Museum in London, are improvising their lines, rather than following a set script. The Science Museum has one of the most extensive collections in the world and no appropriate theatre space. It is among the collections, therefore, that the actors perform, interpreting the objects. Each actor develops a character from research, often provided by a curator, and shapes the outline of a performance for him- or herself. Not all actors have this ability. It takes discipline and maturity. A day of performing consists of one and three-quarters hours out in the gallery in character, a half-hour lunch, and another hour out in the gallery. They improvise loosely on a one-to-one basis and do more fixed performances as larger groups of visitors gather around. It has happened that an actor performs without a break the entire time out on the floor, because of constant visitor interaction. The number of visitors that come into contact with that actor is considerably more than an actor usually encounters in a play within a theatre space. If a museum's objective is to enliven the museum halls and work directly with a collection, gallery characters would be a more effective style.

That brings up another choice: whether to schedule performances or to have them ongoing. As is the case in London, the actors are seen

by a high percentage of visitors because they are out on the floor for long periods of time. Scheduled performances several times a day may not reach as many visitors. However, the time spent watching a scheduled performance is often longer. The nonscheduled performance has a more fluid audience, some visitors staying for a minute and others for thirty minutes. By focusing the visitor's attention for fifteen or twenty minutes, theatre can tackle more complex subjects (Filisky 1989, 21). There are arguments for both.

The Lawrence Hall of Science (LHS) at the University of California at Berkeley produces both improvised and scripted programs through Science Discovery Theatre (SDT). LHS began developing theatre programs as part of a search for new ways of teaching. Gigi Dornfest, now codirector of Science Discovery Theatre with Randall Fastabend, was a science educator there in 1987 through 1988 when LHS applied for and received a grant from the San Francisco Foundation to write and produce three plays. Not having access to similar programs elsewhere, they sought advice from Bay area performers, like "Dr. Science," Dan Coffee.

Later, when grant funding became unavailable, SDT researched and developed SciProv, a format in which science is made accessible to audiences using improvisational sketches and games. In this way, the costs for a playwright would be minimized and informal shows could be presented that would reflect changing exhibit installations. (I realize playwrights might be aghast at this idea.) In SciProv two or three actors, prepared with regard to the science background of a topic, improvise sketches and games with participation from audience members on the exhibit floor. This format enables performers to address a variety of different subjects and has been popular with diverse visitor populations. The format eventually led to the development of scripted programs, based on techniques developed in SciProv. These scripted programs are currently being toured to local schools.

The Museum of Science used improvisation in a project called The Spotted Owl Cafe in the traveling exhibition Hunters of the Sky. The concept for the project was initially developed by the Science Museum of Minnesota. Two actors took opposing sides on the debate about old growth forests in the United States' Northwest. The set for this improvisation was the aptly named Spotted Owl Cafe. The actors

offered visitors who came into the Cafe "food for thought," small wooden squares with suggested discussion points, which the visitors could pick from a large bowl.

When the exhibition came to the Museum of Science, we changed the setup for the improvisation slightly by only using one actor, who played a character struggling between the two sides of the debate. The actor played the part of the owner of the Cafe, inviting people in to sit and have some food for thought. We decided to use this image metaphorically, rather than in reference to the wooden pieces. The actor would begin as him- or herself, clearly defined as a staff member by wearing a Museum of Science lab coat. After collecting a few visitors, the actor would then turn into the character of the owner right before their eyes, taking off the lab coat and donning an apron and a hat. This was done explicitly, with the actor explaining exactly what he or she was doing. Once *in character*, the actor explained his or her dilemma to visitors. At this point, it became a pure improvisation between visitors and the actor about the spotted owl controversy, the pros and cons to cutting old growth forests, and other related issues. The actor did a lot of research, which continued throughout the project.

One improvisational guideline we set up was to always try to bring the discussion around to the opposing side of what a visitor might be saying—sort of a devil's advocate role. For instance, an actor's response to a visitor's point could be "Yes, I see your point. That makes a lot of sense, but now, wait, what about what she just said over there, that makes sense to me too. Can you see her point?" Validating each visitor's contribution was important, but we also needed to avoid complacency and provoke deeper responses to get more meaningful exchanges. The actor asked probing questions like "Can you explain that a little for me?" or "Why do you think you believe that?" The tricky part was to involve people emotionally, but not incite confrontations.

We had four actors rotate in the daily schedule of the Cafe, and while one of our actors thrived and would sometimes get so involved that she wouldn't take a break, another became rigid and asked to be taken out of the four-month project a month early. The loose shape of improvisation, with constant potential for change dictated by the visitor, is not for all actors. The actor must give over a certain amount of

power to the audience, which can be disconcerting. It takes different skills than a scripted play. Sometimes it just takes experimentation to figure this out.

Puppetry creates a vivid and imaginative cast of all types of characters. Furthermore, there is wide array of puppetry styles: marionettes, body puppets, hand puppets, and shadow puppets. Sometimes puppetry can be incorporated into a play rather than using puppetry exclusively. Puppet shows are especially popular among younger audiences, and many children's spaces have puppet stages set up for young visitors to create their own shows. The Musée de la civilisation in Quebec City created a full-body puppet named Mr. Oliver, who interacted with visitors. He became a sort of mascot.

Puppetry in zoos and aquaria is occasionally argued against because of an implied danger of anthropomorphism, the attribution of human or inaccurate qualities to animals. One of the questions that arises is whether we can attribute specific emotions to an animal when we might have no way of knowing whether they have them. However, legends used by storytellers are full of examples of this and yet still maintain the integrity of the animal. We should not get bogged down by strict realism, but maintaining honesty about the subject avoids pitfalls. If the fish doesn't walk on two legs, the puppet should either not walk on two legs or address the discrepancy.

Puppetry remains an underutilized theatrical form for adults. Its long and rich history as public entertainment has been taken over by popular images of children's shows. Many cultures have strong traditions in puppetry arts. In Japan, writing on puppetry can be traced back to 1100 (Brockett 1992, 296). In Turkey and other areas where Islamic law prohibited any representational form of theatre following the collapse of the Byzantine Empire, two-dimensional shadow puppets became popular (Brockett 1992, 94). Puppetry has been for all ages and remains so today. It can be sophisticated and subtle and pack the same emotional wallop as other forms of theatre.

The Monterey Bay Aquarium in Monterey, California, has used puppetry in many ways. It has had assembly puppet programs represent animals in their natural context and presented natural history and habitat information. For younger elementary school children, the

aquarium has presented traditional puppet shows about the behavior of certain animals; for older elementary school children, it has dressed the students in various puppet animal parts to act out the behaviors.

Pat Rutowski, former director of education at the Monterey Bay Aquarium, experimented with the use of theatre and puppetry and found that one of the advantages is that it builds empathy in its audiences for the animals and the problems they might face. It is also a way to present animals that cannot be handled or used for demonstration. However, Rutowski does caution that in an effort to make an animal understandable and create empathy for it, there is the temptation to humanize it (Rutowski 1993, 21). Balance between biological accuracy and these needs is difficult to achieve, but important in order to avoid misconceptions.

Storytellers have libraries of legends and folklore touching on diverse themes, and they can bring these themes to life very simply. The techniques of a storyteller are only slightly different from the techniques of an actor. The storyteller may inhabit the characters of the stories they spin, yet not lose themselves to any one character. The storyteller is always the storyteller relating events. Stories can be shared with participation from the audience, involving visitors in role playing and communal responses. Storytelling can help provide historical and cultural context for a work of art, for dinosaur bones, or for a historic object. Studies have found that sharing a story assists children in many ways. "Both cognitive and affective skills are increased through storytelling. A child's ability to listen and to follow a sequential pattern of events is enhanced by storytelling, and these skills will improve a child's reading comprehension and vocabulary proficiency" (Sternberg 1993, 93).

The Museum of Science used storytelling to augment the traveling exhibition Darkened Waters on the aftermath of the Exxon *Valdes* oil spill. An otter pelt came with the exhibition, which we were given to use as a basis for interpretation. After studying the exhibition components, we decided to research tales from the Inuit culture, which was greatly affected by the spill. We chose tales that had in them the character of the Otter. We mixed biological information about the otter and the aftermath of the spill with these tales into a twenty-minute

storytelling show we called *Tales from the Darkened Waters*. Following a show, one sign of success for us was witnessing visitors make their way from the Science Theatre stage directly to the exhibition, which was in another area of the museum.

I was surprised by the reaction of a museum colleague in Chicago after I described this project. She asked if we had used Native Inuit people to tell the tales. I replied that we had used the actors we had on staff, none of whom were Inuit. She was appalled. When she had done any storytelling, she had sought out people from the culture of the stories. At the time, I was embarrassed that I hadn't done this, but upon reflection I came to believe that what matters most is handling cultural stories with respect. Looking into this issue, I have also found that it is hotly contested within the storytelling community. Robin Mello, an actor with the Museum of Science, has also been a story-teller for more than fifteen years, and is currently pursuing a Ph.D. in Storytelling at Lesley College. In part, it was her experience that inspired us to move in this direction. In an article for *The Lanes Museletter* from The League for the Advancement of New England Storytelling, Robin proposed guidelines that might be used to ensure the integrity of a story: "Be prepared to provide as much factual and contextual information on the culture of the story's origin as you pos-sibly can; establish a rapport and work with a 'cultural authority' when possible; remember that imagination often bridges cultural gaps; have fun; be sensitive to your intuitions" (Mello 1994). Since *Darkened Waters*, I have seen storytellers in a number of museums, and for the most part they are from the culture of the stories they tell. However, most of them were hired only for special events rather than for ongo-ing programs. It is ideal to have actors from diverse cultures on staff. This is certainly not the last word on the subject. We can and should continue dialogue in the field about cultural ownership.

In her 1996 book, *The Passionate Fact: Storytelling in Natural History and Cultural Interpretation*, Susan Strauss addresses the nature and art of storytelling in the context of information giving. She brings into focus our modern-day confusion between what is story and what is fact (or information). Strauss advocates thinking of story as a way in which content is expressed. "This 'story way' could find various forms such as personal anecdote, current event, history, folktale, legend, fable, para-

ble, discourse of scientific fact, fairy tale or myth" (1996, 3). The emphasis here is that science and history are as much story as they are fact. To restrict ourselves by separating the two leaves us with dry, lifeless information and empty stories.

Robin Mello and I have developed a storytelling show for school and outreach programs called The Scientific Storyteller (see Appendix 2). In forty-five minutes, we weave together original songs and stories about animals and the natural world. The premise of the program is that both stories and science are based on questions about how the world works. Science has found new ways to answer the old questions, first answered in stories, and has created new stories based on those answers. Some of the stories in the show are myths, while others are stories from the realm of science. Juxtaposing stories (an ancient way of understanding) and science (a new approach to understanding) creates more models and pictures for the listener, which makes for a deeper, more complex, and complete awareness of the natural world. I believe this juxtaposition is what Bruner meant in bringing together two domains of thought that were previously separate. In the show, to approach the concept of extinction and the interconnectedness of different species, we tell a Scandinavian folktale about the Old Woman Who Weaves the World and the story of a sloth and its relationship to a specific kind of moth. In this latter story, Robin and I take on the character of a sloth and explain its habit of only going to the bathroom every two weeks, which is important in its relationship with the moth. When I am suddenly a sloth, with no costume change and a short prelude, the children are fascinated, and quickly turn to giggles as I slowly climb down an invisible tree to do what comes naturally. It is a great deal of fun! Stories and science are complementary when looking at natural phenomenon and explaining its essence.

The Science Theater Program is experimenting with a new showcase for storytelling at the museum. Previously, we had only created shows that had a beginning, middle, and end and were performed in a contained stage or theatre. We have now prototyped two different sets of stories without a strict progression from beginning to end—one on electricity and one on animals, in new spaces. The first set takes place in our Theater of Electricity, a three-story space with an enormous

Van de Graaff generator and a number of other exhibits. This space poses several challenges: it is very dark normally because of the needs of exhibits; there is no central area in which to perform; and it is noisy. The other stories are told on the Live Animal Stage, situated in the middle of our largest open hall. There are fewer challenges in this space, although noise from the hall can be distracting. Each story-telling show has taken place in between demonstrations in both areas for two 45-minute stretches. Visitors are invited to stay for one or all of the stories, and visitors coming upon it after it has begun are invited to join. The idea has been to have something visitors can move freely in and out of at any time. These two spaces are traditionally unused when there is no demonstration, so the storytelling fills that void. These shows are seen by many more visitors than if they were performed in a theatre space that had only one door.

Both projects have evolved over six months. We worked to resolve the physical restrictions of the Theater of Electricity (TOE) space by establishing a performance area in front of the generator defined by benches and by using a wireless microphone and some lighting. We have also incorporated several activities in between stories for audience participation. In addition, we created new signage. The TOE stories are called Electric Tales and the stories on the Live Animal Stage are called Stories About Natural History.

In Stories About Natural History, a storyteller tells a story behind one of the objects placed around the stage, which audience members choose. For a Chinese robe embroidered with a dragon, we use an ancient folktale to illustrate how thousands of years before scientific method people would create stories to explain strange findings, such as dinosaur bones. We include a discussion about our ever-changing understanding of dinosaurs through science. Most of the stories are connected to an exhibit, which visitors are encouraged to look for after the stories.

This structure has worked well to propel the action of the show and to define a structure for the actor. The biggest challenge of these storytelling shows has been to contextualize the stories—which have ranged from one about Mary Anning, a girl from 1812, to a sloth, to a South American folktale about a bat—with scientific information, while drawing visitors in, keeping them interested for varying amounts

of time, and maintaining a level of theatrical intensity and impact equal to our other productions.

Art museums have used **performance art** to interpret their galleries, which might also use a variety of media simultaneously in a given show. Performance art's mix of media lends itself naturally to museums because the museum's environment can be incorporated as well. Performance art shares some characteristics with other styles. It works directly with the collection and often spins a story. In performance art, the story may lack a traditional narrative or use physical language rather than verbal. The Powerhouse Museum in Sydney, Australia, created a theatrical project with student actors. They performed as a school of fish, swimming through the museum and attracting visitors as they examined various exhibits. It had elements of performance art, such as lack of traditional narrative, and proved successful with its visitors, helping them to look at the exhibits in a new way. A danger of performance art is that it's sometimes too erudite for the casual visitor, mystifying them rather than broadening access to an exhibition.

Participatory museum theatre can range anywhere from entirely participatory in process-oriented creative drama programs to implicitly participatory in play performances. In conference sessions and informal discussions, I have heard audience participation touted a necessary component of museum theatre. I would not disagree, but I would argue that all museum theatre is inherently participatory and is no less so without a visitor volunteer holding a prop. Because theatre is live, there is a two-way dynamic between performers and audience. Therefore, it is never exactly the same and the audience's participation in this dynamic is also why each performance can become a "real" experience, as museum folk say. The decision to have visitors involved in specific ways in a performance must be based on how meaningful that participation will be. It relates to the evolution of hands-on learning and the realization that it is meaningless if it's not also "minds-on."

The target audience for a show can shape the amount and form of the participation used. Large-scale participation is often attractive to

family groups. Hired by the Mystic Seaport Museum, City Stage Company of Boston engaged up to fourteen volunteers from the audience, in funny costume pieces, to help tell the humorous *Tale of a Whaler* at the Seaport in Mystic, Connecticut. The Museum of Science play *One Second to Midnight* did not have any required audience participation, but asked the audience to concur in the argument about biotechnology between the two characters. One actor began the play as an audience member, and several times the actors addressed points directly to the audience. The Museum of Science's adult-targeted series of plays asks the audience to discuss controversial science issues. In these plays, the objective for the actors is to effectively turn the debate over to the audience for a time and then go back into the script.

Questions directed to the audience are more successful at garnering a response if they are genuine, in the sense that the answer is not necessarily known. These questions might probe visitors' opinions or experience. Not as successful is the instructional model used in schools of asking a question where the answer is known, getting a response, and affirming or negating its correctness. This type of questioning is being used less in schools today and seems entirely inappropriate in places of informal learning. Surveys of the audience, asking how many visitors are on either side of an issue, work to break the ice and lead to further discussion.

When interviewing a young girl about her experience after seeing a Museum of Science play (performed by others), she told me that "it was fun. It was sort of different that way from other plays, that you could be involved. Most plays, they don't do that" (Hughes 1993). With audiences often within arm's length, it is difficult to avoid involvement, however passive. The fourth wall of conventional theatre is rarely constructed for museum theatre. Thus, participation is part of the package.

Another potential choice when deciding on which threads and styles of museum theatre to use is between directly interpreting museum collections, as the Walters Art Gallery has done, where the play incorporates an entire collection, or not directly connecting to an exhibit. The Science Museum of Minnesota has found that theatre productions can present scientific ideas effectively when not connected to an exhibit (Filisky 1989, 18). Theatre can be presented as an exhibit in its own

right, as opposed to an interpretive vehicle (Alsford and Parry 1991, 9). The Museum of Science does both. Some of the plays, like *The Bog Man's Daughter*, directly interpret the exhibition and others, like *Mapping the Soul*, have no direct link to any exhibit. The latter style is more conceptual, most often performed in a theatre. *Mapping the Soul* interprets an abstract idea like genetics rather than a tangible object. In the case of this last play, the decision to do it came out of a need to inform Museum of Science visitors about public policy in science. Again, the choice really depends on the needs and mission of the institution.

There are arguments for and against the use of **"real"** versus **"fictional" characters**. By creating an entirely fictional character, you can avoid some arguments concerning authenticity and interpretation. Fictional characters also allow presentations of an "ordinary" person rather than always someone "famous." The Science Museum in London has had great success with such characters and discovered that visitors find these ordinary people more approachable than celebrated "real" people (Bicknell and Mazda 1993, 53). The maid of Madame Curie is freer to say quite a lot more about the life of Curie than Curie herself. The maid's accent and character can be fashioned with less constraint about what she can do and how she might act. Often it is necessary to create a fictional character when research materials are scarce. There is the possibility of creating a fictional character from pieces of stories from several real people. Actress Marcia Estabrook, from Characters Educational Theatre in New England, culls the meat of her characters from many different primary sources, creating composite characters who are absolutely believable and scholastically authentic. On the other hand, there are certain characters in the history of the arts and sciences who are fascinating, and to present their stories from the eyes of another distances the audience and deflates their impact. Primary documents provide us with fully dimensioned portraits of Einstein, Darwin, Monet, or Queen Elizabeth I. Bringing to life a real character also provides the opportunity to resurrect an unknown or unheralded personality, historic or contemporary, as the Museum of Science did with Ada Lovelace.

Decisions about style are almost impossible to make in the theoretical. They must be based on an institution's mission, space, resources,

and needs. What is appropriate for one institution may not be for another. Factors that can affect what is appropriate are audience age, visitor demographics, and geographic location. Something that worked well in Seattle may not in Florida, or vice versa. On the other hand, there are no stylistic restrictions based on these factors. Experimentation can expand the limits of what an institution might think possible.

7

Comparisons of Size and Discipline

What are the differences in demands and expectations between different types and sizes of museums, zoos, and aquaria?

I am often asked how a small museum with limited public space and limited staff hours can incorporate theatre. The short answer is that there is no required budget price for using museum theatre. While larger museums with staffed theatre programs might seem daunting to others, small museums comprising an entire staff of three can undertake theatre. The key to initiating any museum theatre program is the vision and commitment of at least one person. There are various philosophical and practical arguments to support the idea, which are detailed in this book, but most important of all, this central person must decide specifically the reasons they need theatre in their institution. It is this specificity that will drive the program.

As an example, an institution that needs to target new audiences could shape a museum theatre piece to appeal to those targets (family groups, ethnic groups, the deaf community, and so on) and market it as such. Hiring a storyteller from a distinct cultural group or incorporating signed interpretation into a performance might serve those needs best. A historic house that needs to enliven its space has broader possibilities, but it might be helpful to look at an aspect that visitors are not understanding and create a theatre piece about it. If public space is limited, maybe school or outreach programs are the places to incorporate theatre. A school program using creative drama can be as effective and a more simple solution than producing an actual performance.

From this initial impulse, the decision needs to be made on who to hire, which I discuss in Chapter 10. Monetary considerations will drive this decision. An independent theatre professional or a theatre company are options. This will of course depend on the experience of existing staff, but if no one has theatre experience, theatre professionals should be hired. For small museums, a single person will probably be more affordable. A writer/director can sit down with museum staff and work to determine and shape the kind of theatre that would be most appropriate. This person might also be able to train staff or volunteers to present. If someone has theatre experience and can map out the initial shape, an actor might be the person hired instead. Look to the resources in your area. Contact universities with theatre, theatre-in-education, or education programs. The Powerhouse Museum in Sydney collaborated with a local university head of theatre, Gordon Beattie, and his students to create museum theatre. Some community theatre companies might be able to give guidance or support. Network with other museums in your area that might also be interested in using theatre. Performers and writers could be a shared resource. If you can provide ongoing work for theatre professionals, either part- or full-time, a lower negotiated fee might be possible than if you are hiring only for a special event, so do not be put off by set prices. Theatre does not have to be an expensive endeavor.

Where does the money come from? For the most part, museum theatre is supported by soft money—that is, grants from foundations and corporate support. This is true in both large and small institutions. The good news is that museum theatre is attractive to funders. Mixing disciplines, including the humanities, and using innovative teaching methods have become attractive aspects of any museum program. Some museums have found support through underwriting and endowments. The Science Museum of Virginia was able to start up a full-time program with the support of the Carpenter Foundation. Small museums can look to cultural councils in their area. The theatre artist can also apply for funding. Steps for mounting a production are detailed in Chapter 10.

Whatever the discipline of the institution you are working in, there will demands for accuracy—whether scholarly, scientific, or historic. This demand places certain restrictions on theatrical endeavors, but

also gives structure to a piece, which can be helpful. Playwrights working in the field must chart their references and share them with the actors, who might be called upon to clarify points with visitors. Conversely, strict adherence to accuracy can mire a theatre piece in details, so decisions on the level of accuracy should be discussed. Balance and compromise are key to the process.

Of course there are variances within the museum field, by discipline, size, and even within each individual institution. There are some broad content differences. Many children's museums use theatre thematically, to approach subjects like racism, health, and the environment. History museums, though rapidly expanding their repertoire, present historic characters or scenes from history. Historic houses are restricted by space considerations, though innovative tours have solved some of these issues. Science museums have undertaken a range of content, both historical and contemporary. Controversial issues in science also provide museum theatre practitioners with ample material. Additionally, they will often use theatre techniques in demonstrations, as zoos and aquaria do. Institutions working with live exhibits, such as zoos and aquaria, are faced with certain restrictions and challenges. The old theatre maxim to never perform with children or animals, because they will steal the attention, cannot be kept to here. Also, the conservation mission of many zoos and aquaria drives the content of theatre. Outdoor museums and national parks often must present large-scale productions, because of the exterior atmosphere and subject matter, such as a re-created battle. Art museums have been the slowest discipline to pick up the idea of using theatre. Object care and protection considerations have hampered progress, though that is changing too, as it has in historic sites. Some art museums have restricted any theatre to a proper theatre venue, rather than in the galleries, though as at the Walters Art Gallery, that is changing too. Creative drama has been used in all disciplines. There is an especially long history of its application in art and history museums.

What it comes down to is that your mission and your audience will drive what you do with museum theatre. If your "average visitor" is a married couple in their thirties, a play on critical issues in a discipline will be appropriate. If your audience is mainly young families, a story-

telling show using music and movement might be more appropriate. If a show is for the entire range of visitor ages, mixing styles and content levels can provide something for everyone. These choices are organic and individual to each kind of institution.

8

Creative Drama in Museums

Museum theatre is grounded in the larger educational tradition of using theatre to teach about all subjects and aspects of life. How can museum theatre translate the tenets and practices of this more established discipline for its own use?

There are dramatic ways to share information and ideas other than in plays. This book has thus far concerned itself for the most part with presentational museum theatre, such as puppet shows and improvised gallery characters. The presenters of these forms are usually theatre professionals or talented museum staff who are interested in communicating with visitors. In the realm of theatre, there is another form in which the participants, usually but not always children, do not concern themselves with presenting to anyone else besides themselves. This is process-oriented theatre, the field of creative dramatics, or drama-in-education.

There are great differences between the activities and intentions of theatre and the field of drama-in-education. Drama practitioner Brian Way, in his book *Development Through Drama*, calls upon both children and teachers to "discard the limitations of theatrical conventions and consider drama as a quite different activity, calling upon different skills, different standards of judgment and entirely different results. The aim is constant: to develop people, not drama" (1967, 6). That is not to say that drama is not developed and mastered. There is skill necessary to its successful use, but it is within the process rather than in the production of an end product. Consequently, professional acting ability or stage lighting have no place in Way's drama. His focus is on developing the individual, and he cites intuition as possibly the most important single factor in the development

77

of inner resourcefulness as well as for much in life (Way 1967, 5). Harkening back to the classical ideal of educating the whole child with a well-rounded study of the physical and intellectual, drama provides the means to actually experience education by acting out the answers to many academic questions (1).

The formal application of theatrical and dramatic techniques to teaching began at the turn of the century, initially in the United Kingdom and then later in North America and other countries. As has been detailed already, there were earlier instances of the use of theatre in education, but this century has seen the birth of a concentrated movement with inspiring leaders, innovative practices, and strong literature. There now exist a number of organizations dedicated to the development of the drama- and theatre-in-education field, not least among them the American Alliance for Theatre and Education.

This field comprises essentially two movements in one, both of which have their place in museums. Drama-in-education (DIE), which uses a wide array of creative dramatic exercises to teach any subject, is what this chapter explores. Theatre-in-education (TIE), touring performances by professional actor/teachers to schools, is closer to performance-based museum theatre programs previously referred to. Happily, more and more museum theatre programs are incorporating the practice of both forms.

DIE usually engages children in a classroom situation, led by their regular teacher or a specialist, to collectively create drama without need for an audience. The DIE philosophy has roots in how children learn through play to re-create behavior as a way of making sense of abstract or difficult ideas. The practice relies on intuition and imagination, which are also skills to be developed through its practice. It is the process of *doing* that is important. These fundamental principles are translatable to any discipline, and can and should be used in museums just as they are in the classroom. "In the museum children find objects removed from their original context. Helped to understand that these objects once belonged to a particular society and were expressive of that society, children re-create a cultural context for dramatization" (McCaslin 1984, 359). This form is used frequently, though not exclusively, in children's museums. Art museums, such as

the Winnipeg Art Gallery in Winnipeg, Canada, has been using process-oriented drama programs to investigate art for many years.

The Hudson River Museum in New York used drama-in-education in their 1993-94 school programs. An exercise called Here's My Invisible Box was used to help interpret the exhibition Why Collect? which contained objects from many different collections, from those of corporations to a child's. The school groups could not touch the objects. In the exercise led by Joan Kane, the museum's former curator of School Programs, the children used their imagination to pick out an object from the Invisible Box and begin to model using the object. This led to a discussion of what objects are used for, why people collect them, and how a museum exhibits them. Older children eventually began to model the uses of the objects in the exhibition.

Old Sturbridge Village in Sturbridge, Massachusetts, has an interdisciplinary program for school children called Connections— Reading and Writing About History, during which the children explore the site and interact with costumed interpreters. The role play involved here sets the children back in time and allows them to shift the reality for themselves. Working from objects or artifacts creates myriad dramatic possibilities: to teach about a period of painting, a period of history, or the life of a particular person.

An abstract concept can be the basis of a process-oriented museum theatre program. Working with the Texas Space Grant Consortium outreach project Elementary Education Science Through Drama, Jo Beth Gonzales created *Fiddlin' Fusion*, an activity teaching the process of fusion with the metaphor of a square dance, which the students executed (Gonzales 1993, 12).

In her article, "The Art of Participation," Susan Sternberg (1993) detailed her work at the Huntington Art Gallery. As a warm-up activity, Sternberg had visitors briefly look at a work of art. The group then turned away and each had to name something they saw in the piece without repeating what someone else said. It focused visitors' attention and exercised their observation skills. Guidelines for description can be given, depending on the age of a group. In a story dramatization, she had each person in a group assume the posture and gesture of a figure in the scene of a painting, matching appropriate dialogue to the figure. "A member of the group takes on the role of reporter,

interviewing each figure in the now living tableau, asking 'who, what, where, when, and why?' The finale of this activity is a sharing of ideas between the characters in the painting and the reporter, resulting in a 'headline' for the story dramatization" (39). As Sternberg explains, this activity involved participants in the work's setting, characterization, and plot, and gave them the opportunity to problem solve by exploring and seeking answers to new ideas and concepts.

There are many examples of innovative creative drama in museums. Dorothy Napp Schindel and Jennifer Fells Hayes (1994) describe their drama-in-education work in New York museums in their book, *Pioneer Journeys: Drama in Museum Education*. The Museum of Science offered an hourlong workshop called Dramatic Science for second to sixth graders to use creative drama to explore its exhibits. There is a surprising amount of this work going on inside museums all over the world. It is often called by other names, I think, because its activities are closer to playing than to presentation. This form of museum theatre can be appropriated for any discipline and allows for a more concentrated exploration of a subject than is often possible in performance-based theatre. The museum theatre umbrella is wide; hopefully by banding together, all the parts that make it up will make it stronger.

Creative Drama for Teachers

I have given a number of teacher workshops on how to use drama to teach science. Biotechnology and genetics are hot curriculum topics for Massachusetts middle school and high school teachers, and I have focused the workshops around these. In a one-day summer course, I worked with teachers from 9:00 A.M. to 4:00 P.M. In addition to working on the creative dramatic exercises, this provided time for participants to see two Museum of Science plays with appropriate topics: *Mapping the Soul*, about the ethical and social implications of the Human Genome Project; and *One Second to Midnight*, about the pros and cons of biotechnology.

We worked in the museum's Wright Theater, which seats about 115 people. I began by arranging the fifteen to eighteen teachers into a circle and doing simple stretching and loosening physical exercises. Each time I have done this, I am amazed at how suspect the teachers are at

the beginning. They are nervous and hesitant, and for the most part, unfamiliar with creative dramatics. This means that it's important to reassure them that this will be helpful to them and that it should be fun. The last physical exercise I have them do is to warm up their faces by massaging them with their hands. Along with meeting the objective of loosening their facial muscles, this usually breaks them up into laughter, hopefully diffusing any tension.

I begin with simple exercises that help them understand that you don't need lots of stuff to do drama. One of my first questions to them is What do you need to do drama? They might think we need a script, costumes, props, a set, and so on. We whittle the list down together to our bodies and our minds. You can create anything with a little imagination. The exercises I have fashioned for this workshop are slight modifications of theatre games based on the practices of Viola Spolin, Nellie McCaslin, and Brian Way, among others. My friend Terry Stoecker, a drama teacher who has developed many new exercises in her work (that she should write down in a book for others!), has been a constant inspiration and supplied me with a number of appropriate activities.

I begin with simple, general nonverbal exercises and move into the more complex, verbal, and specific (see sample syllabus at the end of this chapter). Sitting in the circle in The Object Game (similar to the exercise used at the Hudson River Museum), each teacher passes around an imaginary object. This object can be anything—like a comb, toothbrush, car, and so on. The way they handle the object tells the rest what that object is. They pass it to the next person, and that person can change it into something else. This exercise can end there after everyone gets a chance and it can give participants a sense of the work to follow, or it can move into the specific by deciding to pass only objects found in a certain place or that have to do with a particular exhibit or subject.

We used the Museum of Science's exhibition on biotechnology as the basis for our work. The group visited the exhibition twice, once before we began working on the creative dramatic exercises, and once after being assigned to groups and given the job of finding an idea from which to create a scene.

One of the most useful and versatile exercises I have found is called The Where Game. Again, in a circle, one person goes into the middle

81

and pantomimes an activity that is done in a specific place. The rest of the group must then guess where this person is. I usually begin this by walking back and forth, looking at my watch, standing with a bored look on my face, searching for something in the distance. It doesn't take too long to have someone shout, "You're at a bus stop!" You can elaborate on the game by having two people work together, narrowing the places down to specific subjects, and adding sounds or speech.

In a project on the human body with an elementary school in Worcester, Massachusetts, I altered this game after the children became familiar with it by having it refer to an activity that relied on one of three parts of the brain: cerebrum, cerebellum, and medulla. We had been working on the brain for a couple sessions. The rest had to guess which part they were using to do this activity. One fifth grader walked around in the circle reading an imaginary book. She turned to me and said proudly, "I'm using two!" Another time with this same group, I asked them to do an activity that a part of the human body would do and the rest would guess which part. Two fourth-grade boys, both native Spanish speakers, began by having one boy in the middle whispering, while the other ran back and forth between this boy and the edge of the circle. He would return to the middle, listen to the whisper, and run to the outer circle again. Realizing he was a nerve cell receiving messages from the brain but not wanting to give it away, I began to laugh in amazement. The boy who was running turned to me, thinking I was somehow chastising his running, and explained breathlessly, "The nerve cells, they go fast." These kids, who were often having difficulty with verbal articulation, were able to translate difficult information into action using these exercises.

The last exercise I used with the teachers, before they moved into their groups and visited the exhibition, was the Flip Book exercise. This is a story-building game. In groups of three to five people, they had to decide on a story to tell with a beginning, middle, and end picture. They arranged themselves into three different tableaux to represent the three parts of the story. The rest of the group watching had to close their eyes before each tableau, so that they would get the full effect of the picture created. From the three tableaux, they had to guess what the story was. This game can then be extended to five or

seven tableaux, adding verbal exchanges and leading to an improvised scene. If given the task to create a scene, a group might falter not knowing where to begin. The Flip Book provides a structure in which to build the scene.

The last activity of the workshop is for the teachers to show each other their scenes, each no longer than ten minutes. I've had groups do everything from realistic tragedy to abstract avant-garde. Once a group of teachers created a bus scene, where they were on the DNA Express. Each teacher played a different part of the DNA. It was quite complicated and surreal, and they had a lot of fun. By the end of the workshop, those same teachers who were so tentative a few hours before were jumping at the chance to do a second scene.

Warm-ups

I. **Physically warm up**, stretching body and face, loosening up.

 a. Shake hands: keep shaking one, stop one and relax it, switch, stretch one hand out while shaking the other, switch . . .

 b. Standing in circle: relax right arm, with the left arm lift and shake the person to the right's right arm.

II. **Object Game,** which can be done using box of actual objects or without. Pass around an object in pantomime, and by what you do with it, everyone guesses what that object is. -

III. **Partners Game:** By walking around, create a handshake that shows what occupation you have. (Hint: Pick an occupation that has an activity associated with it.)

IV. **Machine Game:** One person in circle begins with a sound and motion that can be done for a while. Another person adds another sound and motion to it that is in some way attached. Each person adds to the sound and motions already going. The machine can be concrete or abstract, real or imaginary. A good one for biology study is the

83

human body as machine. *continued*

V. **Instant Images:** Physicalize an image like bacon frying, a raindrop or a leaf falling, popcorn popping, gene splicing, cell division, and so on. One way to start this is by telling the person doing it what they are and to let the others guess.

VI. **Long-/Short-Range Gestures:** Describe something in the exhibit using both long- and short-range gestures.

VII. **The Where Game:** By what one volunteer enacts, we must guess where you are without your making a sound.

VIII. **Title Game:** In groups, create images that go with a given title in three steps, for example, shape–shape–freeze. To warm up, do "the birthday party" or "waiting at the doctors" or "I lost all my research in a power surge." Then, in small groups, have the others guess what the image is by throwing out words.

Exercises

I. **Entrances/Exits:** This looks at reasons for entering and exiting a scene. The first person sits in neutral space and creates an attitude or an activity, and then a second person comes in and has to try to get the first person to leave.

Then the first person has to get something important done and creates a defined space with a purpose; before entering this space the second person must figure out what it is and go in with the intention of getting the first person to help him/her with something else.

II. **Flip Book:** Tell a story in three tableaux with an audience closing their eyes in between them and then trying to understand the story. Freeze in three distinct tableaux that are the beginning, middle, and end of the story, like the surprise party.

a. Try this exercise first without words, then with words.

b. Extend this exercise by adding up to seven tableaux.

9

Museum Theatre
Without Walls

Is theatre outside the walls of the museum still considered museum the-atre? How can museum theatre's integrity be maintained without the context of an exhibition? This chapter shows the evolution of a public program into a school-based outreach program.

Many museums are using theatre in their outreach programming, tour-ing shows to schools and libraries, festivals and special events. In some cases, as with the Pittsburgh Children's Museum, because of space shortages, outreach provides its primary theatre venue. More and more museums are doing outreach, trying to get beyond their walls to reach more people and provide services to underserved communities. Touring theatre pieces is a natural extension for outreach. In these cases, one question that has arisen is whether theatre like this, outside the walls of an institution, can maintain itself as museum theatre. Doesn't it then become simply theatre? It certainly can. There are many educational theatre companies performing in similar circum-stances. What is to distinguish museum theatre from that? In order to be clear about purpose and function, any museum theatre project should reflect its institutional mission in some way.

There is a temptation with a successful piece of museum theatre to separate it somewhat from the museum, to show how good it is on its own. For instance, based on the success of the play's premiere run in a museum, there might be an opportunity to tour the show to other arenas, not necessarily just to other museums. A theatre review in a daily paper is very attractive and, in many cases, appropriate. A play

can become a great marketing tool. If these things happen, it is recognition that this piece of theatre is as viable as anything else in theatres at large.

However, I caution against this line of thinking, because it leaves museum theatre looking like "legitimate" theatre's poor relation. Not because museum theatre cannot be held accountable to the tenets of good theatre, but because it gives the impression that we, the practitioners, in seeking separation from the museum in order to be recognized as successful, do not believe in its basic worthiness. Museum theatre can stand on its own as good theatre, but it cannot stand away from the museum and still maintain the integrity as such.

There are many ways in which to maintain museum theatre's integrity beyond the walls of an institution. One way is to bring objects out to schools. Reproductions can serve as well. Exhibit pieces can be built for transport. Sometimes, none of this is necessary if the play's concept is connected to the institution. However, not all museum theatre can travel. If a piece is so connected to an object that cannot travel, as the London Science Museum's gallery characters are, then it will probably lose effectiveness. As more museums are implementing outreach programming and including plays in their offerings, we must continue to develop the dimensions for what is good museum theatre, and to make sure that if a play does tour outside the museum, it is shaped by them.

On the Road

I rendezvous with my acting partner Brad at the predetermined meeting place in the museum. It's 7:45 in the morning, and we need to load the Museum of Science van with props and the sound system for our school program on the tropical rain forest. We use a two-wheeled dolly to carry the heavy and unwieldy equipment to the van. All packed, we drive to Newburyport, Massachusetts, to do a 9:30 show for the sixth grade.

The Tropical Rain Forest Van Program grew naturally from a play created when the Museum of Science hosted the Smithsonian's traveling exhibition A Disappearing Treasure: The Tropical Rain Forest. The play, a twenty-minute stylized musical, focused on the efforts of slain Brazilian activist Chico Mendes to stop the destruction of the

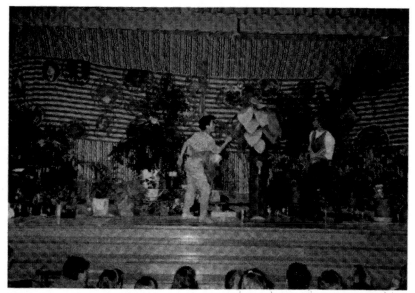

Figure 9–1. Josephina Bosch and Kermit Dunkleberg in *The Ballad of Chico Mendez*. Photo by Eric Workman.

rain forest. Titled in his honor, *The Ballad of Chico Mendes* by Jon Lipsky threads the story of his life from his youth as a rubber tapper through his political awakening to his final confrontations with cattle ranchers, ending with his murder. The stories are told through song, choreographed movement, and the words of Chico and those who knew him. Here his words make up the last song, after the scene of his death in a flurry of taped gunfire:

> When my body is laid to rest,
> don't waste sad words on me,
> don't lay dead flowers on my grave,
> leave them on the tree.

In its initial run as part of the rain forest exhibition, the play evoked powerful emotions in people, while also seeking to educate visitors about the lives of those affected by the fight over the rain forest. It was not uncommon to have someone cry. Teachers began to come up after the show and ask if it could be done in their school. The majority were fourth- and fifth-grade teachers, for whom the study of the rain forest

had become part of the curriculum. As the requests multiplied, the manager of the Science Theatre Program, Mike Alexander, arranged that two actors and a stage manager would informally bring the show to those who requested it. There was worry that without the set and the exhibit to contextualize it, the show might lose its effectiveness, but thankfully, this did not happen.

After a year and a half of touring upon request, it was proposed that the play be part of the newly instituted Van Program offerings. An area bank had donated two vans glossily painted with Museum of Science icons, such as Tyrannosaurus Rex. The play would be supplemented by scientific material from a museum educator. The educator, rather than a stage manager, then traveled out with the two actors, introducing basic information on the geography, soil, and botany of rain forests before the show, leading the school groups in a participatory rainstorm, and introducing the play. The whole program expanded from twenty-five to forty-five minutes.

In its second year as an advertised feature of the museum's Van offerings, the program consisted of only two actors, who absorbed the role of the educator between them. This move was made as a cost-saving measure, but it has had the added effect of maintaining a smoother flow between what is didactically informational and what is metaphorically informational in the program. No longer did we give students the facts about the rain forest first and then present the story. These two things became one. We created a guided imagery exercise at the beginning, taking students on an imaginary walk through the rain forest. The rainstorm exercise led straight into the play. An example of what I mean by metaphoric information is the costume vest worn by both actors to symbolize Chico. It is stuffed to represent his well-known big belly, but has been shaped into the trunk of a rubber tree with cuts in the bark. There is a slash of white paint to represent latex oozing from the tree, but this is also meant to be Chico's blood. We incorporated an explanation of the vest into the beginning of the program, so that students were aware of the symbolism. As another example of didactic and metaphoric information, Darli Alves da Silva, the man who ordered Chico's assassination, has a speech in the play defending himself for cutting down the rain forest, giving several logical arguments and a number of facts. During it, the actor playing Darli

is gesturing with a prop chain saw. The image of the chain saw is menacing. We try to convey that though his methods might not be valid, his arguments are. The play has a very transformational quality to it. The two actors each play many characters, transforming themselves in an instant. The scenes of the play jump from location to location. The style of the play moves from musical to drama to farce and so on. Audiences of boisterous children are transformed too and begin to hush one another as the two actors stalk each other after the first song whispering, "What is it like to know you are going to die?"

Theatre has been recognized as a metaphoric language, while science has traditionally been viewed as objective and factual. Transmitting scientific information has been thought of as a didactic exercise, clearly meant to instruct. However, the lines between the two are dissolving. In search of new or alternative ways to communicate science to the public, science museums and centers have turned to theatre more quickly than have museums of other disciplines. Comparing dramatic and scientific metaphor in her paper "The Dramatic Intelligence and Gardner's Theory of Multiple Intelligences: Connecting Drama to Science Pedagogy," Gonzales (1993) asserts that "both the scientist and the theatre artist rely upon a common 'language' to convey abstract ideas and intangible emotions . . . comprised of metaphoric images" (2). Thus, without the distinct educator role delineating the science from the play, the metaphors in the program are woven together.

The School Performance

Back on the road, we pull into the driveway of the middle school at 9:00 A.M. I inquire at the office about where we should unload the van for the show. The teacher involved directs me and we are soon unloading the equipment piece by piece onto a large proscenium stage, an arch with a curtain. The auditorium seats approximately 400, and we are told by the teacher that the sixth grade who will be attending numbers about 200 students. They have decorated the back curtain with their artwork, large posters depicting scenes from a rain forest. We begin to set up the sound system and the props. A large black metal box houses the sound system, containing a cassette tape deck

89

and microphone receivers. Electric cables connect it to a power source and a speaker. We place the speaker on the right side of the stage, facing the audience at an angle so that we can hear the music as well. We run out of set up time as we begin to do a sound check, and the teacher begins to bring the students in. Rushing, we arrange our props on the stage, and I change into my costume behind the stage curtain.

The students have brought homemade rain sticks, paper towel rolls with toothpicks poked through and beans or rice inside and capped. The previsit packet of activities and information sent out by a museum educator when the school reserves the program provides instructions on how to make these, as well as suggestions on how to create a rain forest set for us. When they turn them over, the beans and rice hit the toothpicks, creating a cacophony of sound much like a rainstorm. As they get seated, we arrange our introduction with the teacher, handing her a laminated sheet of paper. Unfortunately, on this occasion, our sound system refuses to work as programmed. After a short delay, Brad and I agree to go on with the show despite this technical glitch. Luckily, though the music and soundtrack is essential to the show, there are not many cues. I run offstage to manually initiate the music as needed during the performance.

We begin the program by walking out to the middle of the stage, Brad drumming on the conga and me igniting small squares of flash paper, specially treated to burn instantly. The students notice us and quiet down. Brad continues to drum, and as I light another piece of paper, I say, "Each second an area of rain forest the size of a football field is destroyed by fire. You may have heard about this before, but why is it happening, and why should we care? Before we explore those questions, let's take a walk through the Brazilian rain forest." With my last word, Brad hits the conga with a loud flourish and stops. He then informs the students that we are going to need their help.

The first part of the program is participatory. This group was eager to take part in the activities, strenuously volunteering themselves. We hand out large cloth leaves to five children in the front row, which they are instructed to hold above their heads as they walk in a line across the front of the stage. These are our leaf-cutting ants, making their way across the rain forest floor. Two other children come up on stage to be the sloth and the sloth moths. Our stuffed

animal sloth hangs on the arm of the first child as the two children inch their way slowly across the stage, while the second child holds a wooden stick with several feathers attached to it by a clear plastic string directly above the sloth. As this child shakes the stick, the feathers dance above the sloth. Three children are given scarlet macaw noisemakers, decorated plastic cups with strings attached to the bottom. The strings have been wet by a sponge, and by holding the cup upside down and bringing two fingers down the string, the children elicit a loud squawking sound. Ten children are given insect and frog noisemakers. The frogs are clear hard plastic cups with rubber bands around them and the insects are combs with tongue depressors. Plucking on the rubber bands and running the tongue depressors over the combs sounds like a noisy rain forest. One child is given the duty of holding up a decorated green umbrella to serve as our banana tree. We create a rainstorm by having the children rub their hands together, snap their fingers, slap their thighs, and finally, stomp their feet. They are directed by us in sections, creating a wave of rolling sound. When all these parts are arranged, which takes about five minutes, we begin the story of our walk through the Brazilian rain forest. The children have all been given cues and carry out their parts as Brad and I verbalize the story. Our walk climaxes with the rainstorm, and when it is over, I say, "We can now go back to camp to hear the story of Chico Mendes and others that live in the rain forest." Brad tells everyone to give themselves a big round of applause for their part in our story, we collect the noisemakers, and Brad and I position ourselves on opposite sides of the stage for the opening song of the play.

The first song's music and words counter each other, the music sounding light and frivolous and words deadly serious. It begins with "This is the story of Chico Mendes and the victorious moment he led." As we dance, we sing "If you choose to take his lead, you too may bleed." The celebratory tone of the play is at direct odds with the situation in the Brazilian rain forest, where murder is the common answer to the question of who has rights to the land. The playwright, Jon Lipsky, chose to mix the elements of drama, comedy, surrealism, and passion to tell the story. Lipsky describes his intention with the play: "I wanted audiences to be moved by this man's courage." He believes that the way to

educate people is to move them. "If you don't move people emotion-ally, you are not engaging their minds" (Lipsky 1994).

Developed to be presented to public audiences of all ages, the play has many levels of entry. For younger audiences, the music and broad characters are appealing, while high school students often tap into the politics. Chico's story has been of common interest to all ages. One overriding goal of the play is to educate audiences about the complex-ity of the issues surrounding the fight to save the rain forest. Many children have asked why people don't just stop cutting down the trees if it's bad for the environment or the rubber tappers. We attempt to give the other side a voice through the character of Darli Alves da Silva, the cattle rancher convicted of Chico's murder. He argues the case: "Who are we saving it for, rich tourists who want to photograph it, smug professors who want to study it, science museums who want to exhibit it?! We are a poor country. We need to pull ourselves up by our bootstraps. Viva Amazonia!"

Contrary to the seriousness this implies, there are many moments of merriment in the show. Audiences react in different ways to the humor. This group of sixth graders were very quiet during the play, not laughing when I appear in a fake beard as Chico's political mentor, Euclides Fernandez Tavora, nor when Brad plays Maria Aleghretti, an anthropologist who championed Chico's work to worldwide attention. At one point, I play the arms and head and Brad plays the legs and feet of Lucelia Santos, a television star who took up Chico's cause. This is a very silly part, and oftentimes causes raucous laughter.

After the play, we try to explore the difficult decisions people have to make in the rain forest. We pose the question, What would you do if you were hungry and needed food? Someone offers you $10,000 to cut down a tree you own, but you find out this tree's leaves could lead to a cure for cancer. Would you still sell the tree? Whether the stu-dents decide yes or no, we try to play devil's advocate to show that it is not an easy decision, for there are arguments for both sides. Last, we offer the students time to question us. They had only a few questions at the end and a teacher wanted to know what the students could do to help. We turned that around and asked them for suggestions. They suggested recycling, not buying things that require cutting down the trees, and pooling their money to buy a piece of rain forest to con-

serve. We ended with Brad again playing the conga while I lit a piece of flash paper, saying "During this performance over 4,000 fields of virgin rain forest have been set ablaze."

We bowed as they applauded. As we collected our props and packed up, some boys hung around and told Brad they had really liked the show. That was enlightening, because you often wonder when they are being so quiet during the show how they are feeling about it. An audience's reactions do not necessarily correlate with your expectations. Every audience is unique, and evaluation is necessary to delve deeper.

We pack up and head back to the museum, empty the van, store the equipment, and are finished by noon. Our day on the road is done.

In the end, *The Ballad of Chico Mendes* toured for six years. It became a standard part of the curriculum for certain schools. We were asked by some teachers to continue, but we felt some of the issues of the play had become dated and we wanted to offer different programs. Since then we have toured *Mapping the Soul* for high school students and *The Scientific Storyteller* for grades two through six.

It is important to offer schools and other outside agencies outreach programming, if at all possible. In some cases, we visit rural schools that have no connection to the Museum of Science and very little programming at all. There are opportunities to build strong relationships between a museum and a school. An interdisciplinary program like science theatre fits in well with many schools' mandates for cultural enrichment. They have money allotted for this purpose, and they are generally thrilled to have the chance to broaden the scope of what is culturally enriching.

10

Nuts and Bolts

How do you begin? What is the process of doing a play? Should you use actors? This chapter lays out who might be involved and what jobs need to be done to set up a museum theatre program and individual projects.

The impetus to use theatre in a museum usually comes from one person inside the museum. That person either decides to go forward by him- or herself, or he or she is given a mandate to do so by a superior. One thing about all museum theatre is clear: If not done well, it might as well not be done at all. The rate for success will drop markedly if a program is not set up with a number of components. This is not to say that there is only one way of setting things up. The definition of "done well" is relative. A volunteer might achieve that definition as well as a professional actor. Conversely, a professional actor might fail, if other components are missing.

Another way a museum theatre program can get started is by an outside theatre person approaching a museum with the idea or a finished product, which is not usually an easy thing to do. An outside theatre professional often has a tough job in trying to convince a museum that theatre is a viable option for it. This requires the theatre professional to understand the needs of the institution before beginning this relationship. What follows are suggestions to consider when undertaking a museum theatre program. These considerations apply for both the theatre professional who has a foot in the door of a museum as well as the museum professional already working there.

As I have already said, when deciding to use theatre, many factors should be considered. This extends to all sizes of museum, whether

Figure 10–1. Museum Theatre Program Components

beginning with one character giving tours in a historic home or implementing a full roster of museum theatre offerings. Begin with your resources. If no one on staff has theatre experience, a good first step would be to hire someone who does. This might be an actor, a playwright, a director, or a theatre company. Educational goals and exhibit needs, style choices, funding sources, visitor demographics, space, and artistic considerations all play a part in how a museum theatre project goes forward.

First, let's separate the two different processes: setting up a museum theatre program, and producing one show. Setting up the first will provide the essential support for the second. Each institution will be organized differently and use slightly altered language, but the diagram in Figure 10-1 should be translatable.

Setting Up a Museum Theatre Program

The initial component is, obviously, the *institution* and its mission. The decision has to be made that theatre is an appropriate method to employ in fulfilling the mission. The point person in charge of coordinating all the components is usually the *museum educator*. Money

needs to be appropriated in order to begin, though no set *budget* is required. In small museums, there just won't be a lot of money to develop the program. Volunteers are often utilized is such situations. However, it is helpful to keep track of any in-kind contributions, in preparation for the day when you do have money to budget. The *theatre person* hired can have anywhere from all to no responsibility for coordinating the program, depending on the museum educator's job description. This will also change the pay scale for the theatre professional. It's important to integrate this person into the organization of the museum and make very clear her or his purpose. He or she will receive much more assistance and support from the rest of the staff if they understand why this person is there.

A *space* must be allotted for rehearsal and for a dressing room. These can be one and the same. An attached bathroom is essential if using Equity actors. (It's part of the union contract.) This is often completely impossible, but it is helpful even when using non-Equity actors. Performance spaces can be decided up front or on a project-by-project basis, or both. An *exhibition* or *design person* can help here. Choosing the dimensions and location of a performance space will have an impact on the theatre piece. If the performance is done in a small, enclosed area with seating at a maximum of fifty, it will lends itself to intimacy. For complex subjects, this might be advantageous. In a study of *Buyin' Freedom*, a two-character play performed in the Virginia Room at the National Museum of American History, Mary Ellen Munley found the intimacy of the experience important to its success (1993, 85). For more exposure, the space might be open and prominent. The actors with Action Replay, the theatre program at the National Museum of Photography, Film, and Television in Bradford, England, used the front entrance lobby as performance space for its broadly humorous and physical show welcoming visitors. Establishing a space in the museum that always has theatre assists repeat visitors and the staff to know where to go and where to direct people to find performances.

Marketing plans are often overlooked, but they are necessary and can have an impact on the success of a project. If internal marketing, signs, and pamphlets within the museum are not clear or informative about a play, visitors won't find it, which will work against using them to measure any kind of success. Internal marketing is not always easy.

There are usually many different departments' needs to consider. In fact, this has been a frustration at the Museum of Science, where the internal marketing plan has tried to keep signs of any kind to a minimum. Additionally, the frontline staff often have not known about a play. This is a communication problem that we continue to address. We now have a brochure that is available on the museum's publication racks, plays are listed on the daily schedule sheet, and if we need one, the frontline staff makes an announcement for a play.

External marketing can also be tricky. In a large institution, it can be difficult to get individual programs any attention, so that occasionally we have felt like the best kept secret in Boston. On the other hand, a number of institutions have been able to maximize their theatre program with innovative marketing. In fact, the theatre program has become the draw for these museums.

As I described in the first chapter, at the Museum of Science *technical needs* such as lights and sound are controlled by a remote computer system developed by Mike Alexander. The actors are given "genies" similar to garage door openers, which can be pushed unobtrusively to set off a light or sound effect. This allows the actors control of things happening on stage and eliminates the need for a light board operator or sound technician. Many institutions have equipment lying around unused—such as tape decks, speakers, lights, old computers—that could be utilized to build this system.

Optimally, the *evaluation process* should be part of a museum theatre program. This kind of work is still new in terms of research, and evaluation can help to realize its effectiveness and power.

After setting up the organizational structure of a program, it is time to move into the first project. The project could be an improvisation, a play, or developing a gallery character. This will shape decisions about who needs to be involved, and the following is a broad list of possibilities. The time line for museum theatre projects varies greatly. There might be a lead time of a year or as little as two months. The possibility of such a quick production time gives museums the ability to create a show in response to public interest or a scientific controversy, or to solve problems with an exhibition.

Single Project Components

Realize that you don't need to have different people do each of these jobs, but that each of these jobs must be done.

- Playwright: There are many different levels of playwrights. You can get an established writer, who has had plays produced successfully, or you can use a fledgling writer. The point is to get someone who understands the needs of the museum setting.
- Director: Some playwrights direct their own material. It is sometimes good to have a different director to broaden the interpretation of the material. The director is often left out of the equation but is absolutely necessary to shape the work. The writing and acting will suffer without the director's input. The director can also be the person in charge of coordinating the program.
- Actor(s): Not just anyone can be an actor, but there will be the volunteer or the museum staffer who can act.
- Exhibition Planner/Designer: This person(s) must be part of the play production team when working within an exhibition.
- Educational objectives: The play production team must decide these before the play is written.
- Museum staff liaison: This can be the museum educator, the director, or another person. The job is to coordinate the space, marketing, frontline and administration communication.
- Specialist/Curator: This person(s) is vital to research and authenticity, and can be on-staff or an outside contractor. The exhibition planner can also serve in this capacity.
- Stage Manager: Someone must organize rehearsals, collect props, maintain communication between actors and a director, and assist the director in rehearsal. This can also be the museum educator.
- Costume/light/music/sound designers: Hired as necessary.
- Alternatives: There have been a number of museums that have collaborated with schools to create theatre. The Please Touch Museum in Philadelphia used high school students to present plays. The Powerhouse Museum worked with the University of Western Sydney's Head of Theatre to create its experimental theatre projects, and the Orlando Science Center is currently collaborating with a local college in its roster of theatre presentations.

Suggested Steps to Creating Productions

1. Ask, What is it you want or need to augment?
2. If the answer is not connected to an exhibition, decide on educational focus with an intended audience.
3. Hire a playwright and a director:
 a. Set up contracts
 b. Set up time line for research/writing
 c. Discuss style and content
4. Set up a production meeting with playwright, director, stage manager, museum liaison, exhibition planner, exhibition designer, specialist. (NOTE: It's best to have as many of this group together at a time.)

 At this meeting, performance and audience space should be determined. Where the show or character will be performed is vitally important. Is there enough comfortable space for the audience? Will visitors be able to see and hear easily?
5. Audition and cast the actor(s) and/or cast. Usually there is more than one cast, and if so, decide now which cast will be the lead one in rehearsal. Note: Casting can be the joint responsibility of the manager of the program, the playwright, the director, and the stage manager.
6. Set up a rehearsal schedule. This schedule should optimally last four weeks or no fewer than twenty-five to thirty hours. In rehearsal, the director takes over responsibility for the play.
7. Address technical issues. Set up designers, if using any of the following: costumes, lighting effects, music, sound effects, puppets, or masks.
8. Opening of show (and/or exhibition). The first week of presenting a show to an audience often provides opportunities to work out any kinks. After that, the show becomes the responsibility of the actors.

Choosing the Topic of Presentation

The topics of plays can be generated from a variety of conditions. Traveling exhibitions often provide opportunities or present needs for augmentation. In these cases, the play serves to highlight an otherwise overlooked aspect of the exhibition or to explore a difficult

component. Plays can serve to update, enliven, or revise older exhibitions. The Museum of Science's Mathematica exhibit is popular but dated. An alternative to expensive—and unlikely—renovation was the inclusion of Ada Lovelace into that area. The performances of this character provided an apt juxtaposition to the historical tree of mathematicians on the wall next to it, representing as it does only one woman.

At the Science Museum in London, characters were chosen based on the need to interpret specific exhibited objects, such as Puffin' Billy, the oldest steam locomotive. At the Missouri Historical Society, play topics are culled from St. Louis history, in particular racial episodes that have shaped the city.

Densely scientific or abstract subjects become humanized and understandable in a theatrical form. As part of the Museum of Science's mission to educate visitors about public policy in science, plays were developed that presented controversial and contemporary science. The first play in this series explored fetal tissue research. Topics are sometimes picked to reach a specific audience—in this case, adults. Topics of plays are also generated by thematic concerns, like prejudice, multiculturalism and conservation. Some museum professionals have chosen to use theatre to look at the museum itself as an institution, orienting or petitioning their visitors toward or about its identity.

As money becomes increasingly scarce, granting agencies are also suggesting the subject of plays. For example, the Greater Boston biotechnology community initiated funding for a play to explore the pros and cons of its work. The grant stipulated enough money to perform a play on weekends for one year. The fortunate aspect of this arrangement is that the biotechnology funders did not determine the content of the play.

In 1996, the Science Theatre Program had the opportunity to do a play about a subject of its own choosing. We decided to form a focus group of museum staff to brainstorm possibilities. The current craze for the supernatural and interest in alien presence became our focal point. We decided to try to explore what happens to people when there is a UFO sighting. The underlying question we wanted to explore was, What is science? We knew the term UFO would attract attention, so our title became *UFOs Over Massachusetts!?* This was a fun opportu-

nity for us to find a subject not approached in the museum in any other way.

Playwrights

While not every project requires a playwright (if doing improvisation or storytelling, as examples), I cannot overstate the value of a good playwright. For them to be given the raw material of often difficult subjects and then to turn it into clever theatre is amazing to me. Good writing stands out. I have had the opportunity to write two pieces at the Museum of Science, and my respect for playwrighting grew immeasurably as I struggled for inspiration. A playwright is most often contracted for hire, but staff is called upon to write as well. As always, it depends on the talents of existing staff.

Key to a successful relationship between a playwright and a museum is mutual understanding. The playwright obviously must understand the needs of an institution, but the staff of the institution must also know that playwrights need to have time to go away and write for a time. Constant input will cause overload. A clear time line for drafts will avoid this. The time for collaboration occurs at the beginning of a project, when deciding how to focus a theatre piece, and after the working draft is done and changes are made in rehearsal with actors and director. If the piece is to take place in an exhibition, the exhibit developers should be part of the initial collaboration. Informational meetings with specialists or curators provide the raw material. Brainstorming meetings between the playwright, museum person, and possibly the director or stage manager are helpful. Playwrights will often need to visit a site for background information.

When I was the playwright for a collaborative project with Harvard Medical School's School of Addiction about the effects of drugs on the brain, I attended several meetings of Harvard's advisory team for the project; I spoke often with one particular doctor doing the research; and I visited the grounds of a psychiatric hospital and its drug-test laboratory. The site visit became especially important in developing the three characters of the play. This project, in particular, required a lot of give-and-take. I went back to the drawing board several times. We went so far as to scrap the first script after casting and performing it. Neither the

101

script nor the casting was working, so together the director, Bill Gardiner, the manager, Mike Alexander, and I decided to change both. In the end, Harvard seemed happy with both the play and the exhibition. We premiered in a gala opening that included the head of the National Institute of Health's Bureau of Addiction, who was delighted to see the research funded by the NIH made accessible to the public.

Scholarship is important, whether working with primary historic documents or scientific concepts. All references need to be documented so that if asked, a point can be substantiated. Required documentation can be written into a contract. There is no definitive contract when working with playwrights, but I offer a copy of the Museum of Science's as an example (see Figure 10-2). Copyright is shared by the Museum of Science and the playwright. This is not necessarily the same at other institutions.

Copyright is a hot topic of debate in museum theatre right now. It was a discussion point in the conference session Continuing Conversations About Museum Theatre at the American Association of Museums 1997 annual meeting in Atlanta. Chris Runberg Smith led the discussion by reporting that the Missouri Historical Society maintains the copyright to all of its plays. The issue has brought several museum theatre projects to a standstill, with artists and museums struggling for control. It is a thorny issue. The playwright wants to know that the integrity of his or her piece will be maintained, and he or she customarily has copyright. The museum, on the other hand, is used to controlling all aspects of work under its domain. Several scenarios need to be considered. A museum may end up using a play for years beyond its original function. It may become a fee-based program the museum offers to schools. A script may be rented or sold to other museums. Shouldn't the playwright be compensated for any of these? On the other hand, a museum may have the need to shift the focus of a play, cutting it down or changing it in some way. A museum may also want to keep exclusive rights to its material in a certain geographic area or domain. Shouldn't the museum be able to do this? The Museum of Science's solution to these dilemmas was to share copyright. In this case, when the museum rents a script to another institution a percentage of the fee goes to the playwright. If the museum uses the script beyond the original time line stated in the contract, the

Museum of Science

Professional Services Contract

This ___th day of _____, 199 ___, _____, hereafter called the Consultant, enters into a consulting contract with the Museum of Science, hereafter called the Museum. The consulting project will commence on the ___th day of _____, 199__, and terminate on the ___th day of _____, 199__. Both parties agree as follows:

I. Responsibilities
The Consultant shall:
a) research and write a play for the Museum on the topic of _____.
b) provide a set of educational goals for the play.
c) footnote important information contained within the play.
d) provide a bibliography of sources and reference material.
All work shall be done to the satisfaction of _____, Science Theater Manager.

II. Payment
$_____ in four parts:
a) $_____ as soon as possible upon the receipt of this signed contract by the Museum.
b) $_____ as soon as possible upon receipt of the first draft.
c) $_____ as soon as possible upon receipt of any needed rewrites.
d) $_____ as soon as possible upon completion of this contract in fulfillment of the agreement set out in section V(c).

III. Independent Contractor
The Consultant recognizes that s/he is engaged as an independent contractor and acknowledges that the Museum will have no

Figure 10–2. Sample Contract

responsibility to provide transportation, insurance, or other fringe benefits normally associated with employee status. The Consultant agrees that s/he will conduct her/himself consistent with the status of an independent contractor, that s/he will not claim to be an employee of the Museum, including but not limited to unemployment benefits, social security coverage or retirement membership or credit. The Consultant agrees to make her/his own arrangements for any of such benefits as s/he may desire and acknowledges and agrees that s/he is responsible for payment of all income and social security taxes required by applicable law.

IV. Termination

A. This contract may be terminated by either party with two weeks written notice. Upon termination, the Museum will make appropriate payments to the Consultant for work performed through the termination date.

B. As of the termination date of this contract, the Consultant shall furnish to the Museum all statements, accounts, reports, records, writings, keys, parking cards, and other materials as are required or as have been prepared by the Consultant in connection with her/ his responsibilities under this contract.

V. Miscellaneous Provisions

A. Agreement of the Parties: This agreement is a consulting services contract and constitutes the entire agreement between the Museum and the Consultant. The agreement and/or any fees due hereunder shall not be assignable by the Consultant.

B. Governing Law: This agreement and all of the rights and obligations of both parties and all of the terms and conditions here specified shall be construed in accordance with and governed by and enforced under the laws of the Commonwealth of Massachusetts.

C. Proprietary Interests: The Museum and the Consultant agree that the material covered by this contract will be considered

a "work for hire". As such, the Museum and the Consultant agree to share jointly the copyright for this material for 75 years or until either party agrees in writing to relinquish their rights. The Museum has unlimited rights of performance of this material in any venue it chooses for one year after its premiere. After this, the Museum can rent the performance rights at the rate of $_____ per six months. The Museum also has the exclusive right to license other people, groups or institutions to perform the material. Should the Museum license the rights of performance, the Museum agrees to pay the Consultant 20% of any licensing fees received by the Museum that amount in aggregate to more than $_____ in any calendar year. The Museum agrees to pay the Consultant a one-time fee of $_____ for which the Consultant agrees to waive all rights to any licensing fees received by the Museum that amount in aggregate to less than $_____ in any calendar year. Should the Museum fail to perform or license this material for a period of 5 years, all rights revert to the Consultant.

D. The museum agrees to recognize the Consultant as playwright in all advertisements and publications concerning this play that are produced by the Museum.

Agreed to and Approved:

Authorized Signature Authorized Signature
(Consultant) (Museum)

Social Security Number

Date Date

museum pays an additional user fee to the playwright. The playwright is restricted to marketing his or her play with permission from the museum. This arrangement works to provide benefits for each party.

Directors

Most often overlooked and misunderstood, the role of director is to coordinate the writing and acting, adding a layer of interpretation that gives shape and understanding to a museum theatre piece. A director should be involved in all projects, whether using a script or not. The director can make the difference between a talented actor giving an unformed, discordant performance and a talented actor taking visitors on a clearly defined dramatic course. It is especially helpful to have a director assist in shaping a piece written by the actor, which is the policy in some programs. The director can work with the playwright to make script changes in rehearsal. Again, who the director is varies from program to program. It might be the manager of the program, it might be the playwright him- or herself, it might be an actor on staff with directing experience, or it may be an outside contractor.

Use of Actors and Actors' Experience

If a museum theatre program is to achieve its goals of engagement and education, the acting must be good, whether by a professional, a staff person, or a volunteer. The actors are a key component, and bad acting will ruin a project single-handedly. The Canadian Museum of Civilization found that professional actors were critical to visitor satisfaction with its live interpretive theatre, citing "the actors and the acting as the reason they stayed at a piece" (Rubenstein and Needham 1993, 125). Once the play has opened, it becomes the responsibility of the actor or actors. They perform the play as rehearsed, but continue to grow, working with audiences and each other (if performing together). Performances often improve long after the opening. While actors study the topic of a play or character in rehearsal, they must be continually aware of new developments, especially for plays on current science. This has been especially true for the actors in *Mapping the Soul*, a play about the Human Genome Project. The news media are

full of updates, and the actors have had to keep up with them. However, actors are not expected to know everything about the subject of the plays they perform. They are, after all, hired for their communicative—not scientific or historic—skills. To admit ignorance to a question is absolutely acceptable, and much better than providing incorrect information. The Science Theatre Program's official policy is that no visitor leaves with a question unanswered, and actors are instructed to have the visitor write down their question, name, and address, and a Museum Educator will mail the answer to them. This might happen twice in a month of performances at the museum. This system has worked well over the course of the program's existence.

Actors are chosen for their ability to effectively communicate as well as their ability to act. The communication involved in this work goes beyond just presenting a play. In traditional theatre, the audience is not privy to the world behind the theatrical magic. The lights dim, the actor bows and walks off stage, and the curtain comes down. In museums, rarely are there curtains, let alone a backstage, and the audience is within physical reach. Others in the field have stressed the need for good communicative skills in actors. Robert Finton from the Maryland Science Center coined the term *actor/demonstrator*, a sort of hybrid, to expand the definition of the actor's role in museum theatre, recognizing that, especially in science centers, demonstration is part of the form. I agree with Finton when he states that "perhaps the most appealing aspect of museum theatre is when the 'curtain comes down' and the audience can ask questions, inspect artifacts and props, make comments, and interact with the performers" (1992, 3). Anecdotal evidence of learning is often most powerful here.

It is a strange thing to be an actor in a museum. Not only are we working toward educational and theatrical goals, but we are also constantly explaining what we do. It is sometimes comical, sometimes frustrating. "Are you kids students?" "You were great, you should go to Broadway." "Do you work for the museum?" "Where did you study?" We hear all sorts of questions. Acting is a line of work that most people believe exists only on a television or movie screen. Otherwise, it is perceived as a hobby. I believe that may be why visitors will often assume that a thirty-five-year-old actor is a student. It doesn't register as a real job to them. This brings out the missionary in me. I want

people to understand that this is my job, from which I earn a living. Sometimes it's not that easy to do, after you've just done a play in which you're using all of the talents and technique that you've developed and refined over years. We would all like it to be obvious, but we must remember that theatre in a museum is a surprise, and visitors are intrigued when they experience it. I like to explain that we have a whole program of theatre and I then give them a brochure. This is also marketing for our school programs. We've booked a number of them from teachers and parents who first saw a public play performance.

City Stage Company has developed an interesting theatre program at the Boston Children's Museum called Kidstage, a space designed to allow kids to play on when it is not being used for a performance. One of the goals of the space is to teach children about theatre. An automatic system of switches is activated when a child roams onto the stage. A recorded voice welcomes them and explains the stage and some possible actions. Short pieces of different kinds of music play. There is a large wooden chair with a cape draped over it for children to use in developing a story.

I first explored this space with a ten-year-old. She waited until other visitors had left and then jumped on stage. She danced, inspired by the different cultural styles of each piece of music. She then sat down on the chair, wearing the cape, and told me the story of two swans, beginning with the universal "Once upon a time. . . ." I was very impressed by the stage's user-friendliness. This ten-year-old did have some experience seeing theatre, but still, never hesitated to utilize the functions of the stage. In performances, some of the tenets of theatregoing—quiet during performances, applause at the end, audience-performer relationship—are explained. With any luck, these children will grow up to not be surprised to find theatre in a museum.

So it should be with consideration beyond acting talent that actors are selected to become part of a museum theatre program. It is not for everyone. When auditioning actors, we present them with some of the issues involved in museum theatre, like mobile audience members and attrition, noisy exhibits, and the close proximity of the audience. The intimacy of some of the performance spaces requires very honest, subtle acting, because a false note in the performance shows quickly under these circumstances. The large, expansive Broadway show style

can overwhelm an audience and is not necessarily appropriate. Many actors have found it unsuitable to their way of working. It is hard to do on a daily basis. There are days when it feels more like guerrilla theatre, fighting boisterous exhibit halls and disruptive crowds. On the other hand, it can be one of the most rewarding and satisfying jobs. There is a sense of real personal achievement in this work. Justine Serino, an actor with the Museum of Science from 1987 through 1994, characterized her experience in Science Theatre thus: "I didn't expect to love it. You watch people leave a performance understanding or thinking about something that they hadn't before" (Serino 1994). When asked how she viewed this work, she advised that "the key to this work is finding the 'art' in what you are doing. That is how I make it legitimate for myself as an actor. It is the key to being professional." Actors might perform a play every weekend over the course of several years. In order to keep the play fresh and make performance number 1,237 as good as number 2, actors must call upon their acting technique. If actors approach this kind of work as just a job, without art, it loses its impact.

The highs far outweigh the lows. How many work experiences include a constant and impressive ratio of positive feedback? On a very basic level, it is theatre and education at its most essential and dynamic. It puts theatre in contact with something larger than itself. The opportunities to be in touch with this value of theatre are few in the conventional theatre world, often blocked out by commercial concerns.

At the Museum of Science, actors audition and are hired to perform a specific role. Some actors eventually work into a repertory of plays in the program. They audition on a project-by-project basis, for although they have been hired to work in the program, each actor is not necessarily right for each role. On the other hand, we try to accommodate peoples' strengths by incorporating them into what we might do. Science Theatre actor Robin Mello's storytelling ability inspired us to begin using this form of theatre. We look for actors interested in education, and many have theatre-in-education experience. The investment of time and money to train a new actor requires us to ask for a six-month commitment. We have found it important to have a flexible scheduling policy, so that actors can perform plays in other theatres while acting at the museum. This can avoid burnout and staleness.

109

We also attempt to diversify with our hiring policies. We keep an active file for nontraditional casting. In the instance of casting the character of Charlotte in Mapping the Soul, who is legally blind, we hired an actress who actually had a similar blindness. We have tried to break down stereotypes by casting interracial couples when their race is not the issue of the play. The museum's Task Force for Diversity created a series of vignettes on diversity issues shown at all-staff meetings in 1994. Using staff members with theatrical experience (though not necessarily Science Theatre actors) who were overseen by the Manager of Science Theatre, the vignettes highlighted with humor and incisiveness dilemmas faced by visitors and staff without being threatening. There is much more to be done in this area, but theatre provides a clear opportunity to be inclusive.

There is much discussion among museum theatre professionals on the use of actors. There are suspicions in the museum community that artistic license will win over scholarship. Actors might distort information. However, good actors are trained to be able to give a quality performance, time and again. I reiterate former Science Museum of Minnesota actor Margaret Chase's belief that if actors are working with a script, variations in content and concept are few (Grinell 1979, 20). With proper training, actors can be aware of the potential problem. It is important for managers to be clear about what they expect when hiring actors. I have heard accusations that actors' egos should prohibit their employment, because as soon as Broadway or the West End comes calling they will leave. However, any employee would be tempted to leave a position for better pay and exposure. Part of the job of being a good actor is being professional and honoring commitments. That means arriving on time, prepared and ready to work, with the tools to fulfill the task. A talented actor is a considerable asset to a museum theatre program. Bad acting is bad acting wherever it's performed and has the same end result: no one will want to watch. Robert Finton addressed the issue at a session on museum theatre during the 1993 Association of Science-Technology Centers' conference, pointing out, "You can teach good actors good science easier than you can teach good scientists good acting." Actually, I have felt that my nonexpert status has had a positive effect for translating scientific information to the lay person. If I get it, maybe they will too.

There is no hard-and-fast rule to use actors. Past and current museum theatre has been done successfully using high school students (Chicago Academy of Sciences), volunteers (Henry Ford Museum and Greenfield Village), and college students (Powerhouse Museum). If the work has integrity and is of good quality, the background and title of the performer should be irrelevant.

Development of a Museum of Science Play

By way of illustration, the following is a narrative account of how the Museum of Science developed its play *The Bog Man's Daughter*. Money was earmarked in the grant for the Bogs exhibition at the request of the Exhibits Department. The Exhibit Planner and Exhibit Designer both thought a play would be an asset to this exhibition. They had been unable to acquire loans of artifacts from Ireland to include in the exhibition and they felt the play could impart a strong Irish flavor. With approval from the funding source, a quarter of the $100,000 exhibition grant was earmarked for the development and performance of the play. At this point, the museum's Development Office, which wrote the grant proposal, the Exhibits Department, which sought funding, and the Programs Department, which agreed to be part of the grant, had been involved. The Manager of Science Theatre then hired the playwright, Jon Lipsky, who had worked with the museum on several occasions.

Maintaining the wishes of the exhibit team to have an Irish theme, the playwright set the play in Ireland. The Planner and Designer had taken a research trip to Europe and Ireland, returning with books and materials. Educational goals for the play were discussed in terms of the botany of peat, its uses, and some of the discoveries made by peat cutters. The playwright was shown a computerized floor plan of the exhibition and with the Exhibit Designer, settled stage requirements. One of the pieces of research material supplied by the Exhibits team was a photograph of an Irish woman on a bog. The playwright was given this, in addition to many books, five months before the exhibition's scheduled opening.

The frequency of shows and the number of actors were determined by the grant amount. The majority of the $25,000 would go toward the

actors' salaries to perform the play four times every day for the six-month duration of the exhibition. Through trial and error, Alexander and others had determined the length of Science Theatre plays taking place in an exhibition at approximately twenty minutes. Twenty minutes allows enough time to explore an idea. Shorter plays felt unsatisfactory or unfinished. Visitors also seemed able to commit to a twenty-minute program without worry. Plays are scheduled on the half-hour at the Museum of Science, while demonstrations are scheduled on the hour. Visitors can take in both if they want rather than having to choose between the two programs. Adult-targeted plays taking place inside one of the museum's theatres are generally thirty minutes long, taking into account longer attention spans and more complex subjects.

Within this framework, the playwright had artistic license to create the play. He decided to use the photograph to develop the character. Jon Lipsky's method includes taking in all the material given him and then trying to forget it on a conscious level, to just live with it and let ideas float in. He looks for a way into the subject, in this case the woman's picture, and then focuses on making connections to it. "I look for things that move me. Then I ask the museum staff what information is most important to them, rather than trying to jam everything in" (Lipsky 1994). Another discussion point in meetings about the play's possible focus included its connection to the Irish population of the Boston area. There is a strong history of Irish immigration here, and the immigrant's dilemma, to leave her or his homeland, continues to be a common one for a variety of cultures in the Boston area.

Roughly ten weeks later, Lipsky completed a first draft, which was read by the Manager of Science Theatre and the actor who would work with the playwright, now in the role of director, in developing the final performance. The Exhibit team was also given the draft for their approval. With feedback from the manager and actor, the playwright pared down the script and went into rehearsal with the second draft. A second actor had already been cast from the Science Theatre Program to perform the play as well, and she would go into rehearsal after the script was thoroughly developed.

Rehearsals took place over a six-week span, often just one morning in a week. The playwright/director and the actor worked out the schedule. The greenroom—a theatre term for the dressing room, resting

place, and office—served as the rehearsal space. The actor, playwright, and manager decided to hire an Irish theatre director in Boston as a consultant to work with the playwright and actor for authenticity in language and accent. She taught the actor an Irish phrase as well and choreographed an Irish dance into the play. A musician collaborated with the playwright to compose two original songs, as well as sound effects, such as a thunderstorm. The Science Theatre Assistant hired a costumer to build a costume that would be as close to the photograph of the Irish woman as possible. These theatre professionals, as well as the actors, were from the Boston theatre community. The Manager of Science Theatre Program attended many rehearsals and began making or collecting the props needed: the slaene for digging, the old basket for peat, the black kettle, and the pail. He also worked with the playwright in designing the lighting effects. Eventually, he programmed the computer to run the lights and sound.

With the exhibition's opening two days away, rehearsals moved to the stage. The transfer from rehearsal room to stage provided a startling dose of reality. The actual stage area was considerably smaller than had been mapped out in rehearsal. The performance area was located in the back behind freestanding walls in the exhibition, virtually concealing it from the entrance. Exhibit components restricted the audience area, and there were problems with electrical power for the lights. None of this was any one person's fault, but was rather the result of faulty communication, and the immediate needs were worked out with everyone's cooperation. This is not an uncommon occurrence and highlights the need for good communication. The play opened with the exhibition and all those involved were pleased with the result. The Exhibit Planner, Maureen McConnell, expressed her satisfaction with the outcome: "I personally feel that the play is the single most powerful element in Mysteries of the Bog. Performed as it is within the exhibit hall itself, it is the heart of the exhibit both literally and figuratively" (McConnell 1994).

This example has elements common to each of our plays. There is always collaboration between the playwright and other museum staff. If the play is developed with outside specialists, as was the case with our recent play on drug abuse, which involved doctors from Harvard Medical School, those experts are included in the collaborative

process. At times, with difficult subjects like biotechnology, the playwright might need additional scientific input from the expert. At times, as was the case with *Two of Every Sort*, a play on sexual reproduction and gender roles, which is a highly charged field, the collaborative process can take on an added political significance. Certain staff members had very particular ideas on the subject that they wanted to make prominent in the play. This did not necessarily gel with theatre team's views. Important to the success of the collaborative process is mutual respect for expertise: the playwright's artistic and the museum staff's discipline.

11

Learning and Evaluation

What meaning do visitors make from museum theatre? How can we influence what visitors might learn? What methods might best bring understanding of the experience? Can we measure the effectiveness of museum theatre?

Learning

How do we come to endow experience with meaning? Jerome Bruner (1986, 15) classifies this question as one that preoccupies the poet and the storyteller, and it is certainly a question that occupies the museum theatre practitioner. How can we manifest museum theatre with purpose and significance? As the museum field explores how visitors make meaning from them, so should the museum theatre field in particular. How visitors learn from theatre is distinctive within the museum, because it appeals to visitors' hearts and minds. To illustrate, I will use descriptions of two modes of thought Bruner explored in his book *Actual Minds, Possible Worlds:* paradigmatic (or logico-scientific) and narrative. The first is concerned with knowing something from verifiable reference and empirical truth. The second is concerned with knowing something from verisimilitude, or the appearance and believ-ability of truth. Bruner cautions that efforts to reduce one mode of thought to the other will fail to capture the rich diversity of thought (11). Though it seems natural to associate museum theatre with nar-rative thinking, I believe we are also working in the paradigmatic. Whether operating in art, history, or science, museum theatre attempts to meld the "facts" of the discipline into the narrative that will ring true. For example, in *The Bog Man's Daughter* the chemistry of bogs that cause them to preserve bodies is explained in relation to

the character's fear of coming upon one of the bodies. The audience must believe in the character's fear, as well as understand why the bodies are so well preserved. Based on Bruner's thinking, visitors will make meaning from museum theatre if we create strong, believable narratives imbedded with images and models, either physically or imaginatively, based on empirical truth.

Understanding how people make sense of an experience is fundamental in creating museum theatre. To ignore the human need to have a story be believable will shatter its worth. Like Bruner's two modes of thought, different theoretical constructs in developmental and cognitive psychology can provide guidance to the museum theatre field.

Though I know of no theatre project that based its practice on advances in cognitive psychology, there are museum projects that have and that could inform museum theatre. Harvard Graduate School of Education's Project Zero collaborated with the Isabella Stewart Gardner Museum in Boston on a program to create a broader base of visitors, as well as broadening their museum experience. Based on Project Zero codirector Howard Gardner's theory that people have different styles of perceiving the world, the program encouraged the Gardner Museum's educators to create "windows" through which visitors could enter the museum's collections (Dezell 1993, 24-25). Along with Gardner's theory of multiple intelligences (1993), which delineates different "intelligences" (linguistic; logical-mathematical; musical; spatial; bodily kinesthetic; interpersonal; and intrapersonal) that determine the ways individuals absorb information, the educators used Gardner's more recent proposal that there are "windows" or "entry points" based on these intelligences, to allow visitors ways in to make sense of and understand an object. The museum educators framed questions for visitors to consider under each of the five entry points (narrational, logical-quantitative, foundational, aesthetic, and experiential). For example, as they looked at a painting visitors were asked, under the Narrational entry point, "What do you see happening in the painting? Is there a story being told? Who is the main character?" (Dezell, 25). Developed for an art museum, the entry point questions can be altered slightly for a science museum, history museum, or zoo experience, the common ground being the determination

to provide a variety of ways into the experience. Museum theatre is a vehicle that can provide many windows into an exhibit or concept by framing questions within the context of a piece of theatre for audiences, as well as by using these questions to shape its creation.

Melding theory with practice retrospectively, again using *The Bog Man's Daughter* play as an example, the entry point questions could be thus:

- Narrational: What is life like on a bog? How will this character decide between life in Ireland and life in America?
- Logical-quantitative: What is a bog? What is peat made of? What is it used for? What are the special properties of bogs?
- Foundational: What does this woman's story tell you about bogs? Would you like to live on a bog?
- Aesthetic: Would you describe the play as enjoyable? Did you like the music? What does a bogland look like?
- Experiential: Were you moved by the story? Would you like to help build a structure of turf called a *foote*? How would you walk safely through a bog?

Howard Gardner has long been a proponent for the idea that museums are rich learning environments. In his book *The Unschooled Mind,* he suggests that schools should be more like museums (1991, 203). Likewise, Gardner supports the idea of using the arts to teach other subjects. He proposed that arts education provides a new approach to learning beyond the traditional linguistic and logical modes of cognitive development (236). Thus Gardner and Project Zero have provided museum theatre practitioners with a possible guide for future plays and support for the belief that theatre can reach a vast audience of learners in museums.

Theatre provides for a multiplicity of experiences shaped by the visitor. It is a microcosm of the larger museum experience, each forged by current educational theory. Like the model of the constructivist museum espoused by George Hein (1997), museum theatre allows visitors to make connections and create meaning for themselves, based on their past experience and understanding of the world. "Constructivism argues that both knowledge and the way it is obtained are dependent on the mind of the learner" (Hein 1995, 15). This leads to a variety of

117

learning outcomes, rather than just one. Each person goes through this process differently, based on personal knowledge. This does not mean that museum theatre never agitates visitors' previous understanding, and in fact, in many cases, it does exactly that. Again, it goes back to Tilden's tenet that interpretation must not become mere instruction, but should provoke. Museum theatre provides opportunities to effectively question visitors' misunderstandings and assumptions about the world, whether it be about animals, art, or an event in history. Museum theatre can do this effectively by constructing scenarios that create a safe distance between the audience and the players in which visitors can work through these ideas. The visitor is in charge of the experience, and with the constructivist model in mind, incorporates this into his or her schema of understanding. This corresponds to Dewey's principles for the educative experience. We must shape museum theatre so that it is part of the world, can be assimilated into visitors' experience, and be used to build on their future experiences. For instance, rather than choose to create a play about what a gene is in isolation, the more meaningful position would be to create a play about how knowledge of our genetics is going to change all of our lives and make connections to corresponding issues. In another case, given the challenge of interpreting a landscape gallery, rather than give an explanation of the technique or history of a painting, you could tell stories that relate to the images, and connect people's experience to the art. Stories, modern or ancient, can contextualize the art by opening a window on the cultural context from which the art emerged. And so the journey begins relevantly in ordinary life, is made applicable, and then expands.

A poignant example of how a museum theatre experience can build upon visitors' understanding and question assumptions happened in the museum's Spotted Owl Cafe series. Each interaction between visitor and actor required the visitor to contribute her or his idea of how the actor's character should decide which stand to take concerning old growth forestry. Without realizing it, visitors would counsel based on their understanding of the situation and the science involved, to which the actor would respond as a mild devil's advocate, elucidating the structures on which the visitors had based their understanding. There was no right answer in the end, aside from the new awareness

of the process of making a "scientific" decision about a difficult and divided issue.

Though specific learning goals are necessary and can add dimension to a theatre piece, the overriding power of theatre as a learning tool is to inspire, motivate, and stimulate curiosity. Plato, among others, pointed out that the beginning of wisdom is having wonder about your world. I am reminded of the adage that to give someone a fish is to feed them, but to teach them to fish is to allow them to feed themselves. There is a continuum of outcomes that museum theatre must produce in order to achieve such lasting effects: to initially captivate and amaze, which then moves into reflection and genuine inquiry by providing information within a strong, believable context; to stimulate questions and connections; and finally to satisfy the human need for a good story. There is another phase that occurs later, when the visitor adds another experience to his or her schema: to retrieve the past narrative imbedded with information—fishing, as it were, for more sustenance.

Evaluation

We cannot ignore the need for evaluation of museum theatre, yet we must not feed into the idea that the only proof of its educational worth is in cognitive studies documenting the acquisition of solitary data. In addition, evaluation needs to delve beyond the perception that a museum theatre experience is positive or negative. Keeping in mind the aspects of learning already explored, evaluation must provide ways of understanding the larger experience. "If learning is making connections in a network, then research into this learning must be devised that can ascertain degrees of connections, not knowledge of isolated facts" (Hein 1997a, 11).

So far, most studies conducted on museum theatre programs have not gone far beyond these preliminary ideas. Significantly, what they have done is to establish the notion that using theatre in a museum is appropriate, that visitors respond by-and-large positively, and to show evidence of visitors' acquisition of new data.

Two large-scale evaluations of entire theatre programs are from The Science Museum (1993) in London and the Canadian Museum of Civilization (1992) in Hull. Each report looked at a variety of

museum theatre experiences offered in the institutions and used multiple methods for collecting data. Both showed consistently positive results in terms of visitor reaction to museum theatre (Bicknell and Mazda 1993; Rubenstein and Needham 1993). One of the things the London study sought to find out was whether or not visitors were embarrassed or uncomfortable by being confronted with an actor in character in the gallery halls, which can happen easily if not done well. Over the years, I have heard this mentioned as a concern by a number of museum people. Happily, this did not seem to be the case for most visitors there. Rather, 95 percent of the visitors surveyed expressed the view that drama in The Science Museum was a good idea (Bicknell and Mazda 1993, 2). In addition to supplying supportive data, the Canadian Museum of Civilization's evaluation provides a detailed picture of its comprehensive live interpretation program's practices and goals.

Changes in attitude have also been measures of theatres' effectiveness. Zoo Atlanta embarked on a theatre program in 1991 and studied how its shows satisfied the zoo's conservation mission. Surveys of 200 audience members "showed a change in attitude in the direction that favors environmentally responsible action, with significant changes in attitude on the questions measuring knowledge on issues dealing with endangered species and conservation and basic attitudes about wild and domestic animals" (Davison et al. 1993). This avenue of attitudinal change is rich for more study.

There are already a number of studies out there that show that museum theatre is having a positive impact on its audiences. The Science Museum of Minnesota, the Walters Art Gallery, Colonial Williamsburg, and the Aquarium of the Americas all have conducted studies of their museum theatre projects.

Evaluation at the Museum of Science

In several single-program evaluations, Lynn Baum, an in-house evaluator at the Museum of Science, found positive perceptions of learning. After seeing the play *Stuck in Time*, by Jon Lipsky, from the Trapped in Time exhibition on the La Brea Tar Pits, visitors were asked to rate the educational content on a five-point scale with a rating of 1 as not

being educational and 5 as indicating very educational. The majority rated it a 5, and when combined with the percentage that rated it a 4, visitors who were very satisfied with the educational quality of the play equaled 87.6 percent (Baum 1991a). Formative evaluation was used in determining the balance of perspectives presented in *Mapping the Soul.* Though the majority of visitors felt that the play's views on the Human Genome Project (HGP) were balanced, there was a minority who felt that it wasn't balanced, that it was slanted against the HGP. The play was changed slightly to offset this perceived imbalance. In a more open-ended evaluation of the play *The Ballad of Chico Mendes,* visitors were asked to write their comments down on three-by-five-inch index cards left on the seats, and over the course of several different shows, 92 visitors responded. Most comments focused on one or two aspects, though not necessarily the same one or two. Eight categories were coded from the various responses: overall impression; lyrics and melody of music; quantity and accuracy of information; the physical site of the theatre; appeal to a broad range of ages; participatory nature; quality of actors; and the inspirational quality of the play (Baum 1991b).

It is interesting to note what issues visitors chose to write about without any lead from the museum. To illustrate, 27.2 percent of these visitors remarked on the appeal of the play to a wide range of ages, though some disagreed: "good way to present 'difficult' material to children"; and "geared more towards adults due to the language/vocabulary" (Baum 1991b). The play was written to appeal to a wide range of ages, but complex issues, such as Chico's assassination or the Extractive Reserves he set up, were not sugarcoated for children.

Plays have also been included in larger exhibition evaluations. In their study of the Mysteries of the Bog exhibition, Cuomo and Hein (1994) found that visitors stayed in the exhibition longer when the play, *The Bog Man's Daughter,* was in progress, whether they appeared to be watching the play or not (5). Could this mean that some visitors listened to the play while looking at other exhibition pieces? In follow-up telephone interviews, when asked what they remembered most clearly, 35 percent mentioned the play (Cuomo and Hein, 12). That is remarkable in light of the fact that not all of the respondents actually saw the play.

In 1997, we evaluated the play *The Masque of Leonardo,* by Jon Lipsky, as part of the temporary exhibition Leonardo da Vinci: Scientist, Inventor, Artist. Mike Alexander and I decided to focus on visitors' perceptions of the play as a value-added experience in the exhibition. The exhibition had a large number of components aside from the play, including a multimedia introduction and several interpretation stations, staffed by volunteer interpreters. The play happened at least every hour at the end of the exhibition and had the goal of summing up the experience for visitors. We wanted to know what connections the visitors were making between the play, the exhibition, and the subject (Leonardo), and whether they found this valuable. We were also working under some initial criticism of the play by some staff and volunteers that it was too stylistically avant-garde. Lynn Baum designed a survey questionnaire with us, and a museum education fellow was assigned the task of collecting the data. They were also asked to fill in observation sheets each time data was collected. The observations were used to provide some context for the data collected, regarding audience size, physical response, and general atmosphere, with possible outside influences like large group movement through the area. Preliminary findings have been extremely positive. 95 percent of the visitors surveyed found it a value-added experience (Adolphe et al. 1997). Within this group of visitors' statements, four categories emerged: generally positive; those who related the play to the exhibition; those who related the play to themselves; and those who related the play to da Vinci. It was particularly gratifying to see evidence of visitors relating the play to themselves: "It made me open my eyes."

George Hein (1997b) has counseled evaluators to use the same model for evaluation as is being evaluated—that is, a narrative would be used to explain a narrative. Quantitative evaluation gives us useful information but is limited. It does not tell us how people responded and why. It does not tell us how to make better museum theatre. Qualitative or naturalistic methodology provides us with tools to look beneath initial responses. Observation, interviewing, and innovative techniques such as providing the visitor with data collection devices to use during a theatre experience, like a tape recorder, will produce rich data for analysis. Penetrating methods of analysis—categorizing beyond initial positive and negative responses—will illuminate further.

There exist implications from new studies into museums and learning for museum theatre. Work such as Beverly Serrell's (1997) might have ramifications for museum theatre. She postulates that the amount of time visitors spend in exhibitions can be indicators of learning (Serrell 1997, 108). Museum theatre holds visitors' attention for twenty minutes or more. What does this mean for visitors' learning? The possibilities for profound learning experiences with museum theatre are great; it's necessary to find ways to best articulate exactly what that means.

12

Ethics and Values

Is there a code of ethics in museum theatre? How do values color it? Should museum theatre be used to approach value-laden controversial subject matter? This chapter explores how the consideration of ethics and recognition of values relate to the practice of museum theatre.

The power of theatre is strong. It not only surprises visitors, but it can tap into very deeply held beliefs and understandings about the world. It is a serious forum with a potential of sparking deep emotions. In other arenas and other times, it has been recognized as such and been used to fuel religious fervor and political change. Brazilian theatre director Augusto Boal, author of *Theatre of the Oppressed*, has used theatre in the political arena. He became so prominent and popular advancing workers politics with theatre that in 1992 he was elected to Rio de Janeiro's city council.

Early on in his work, Boal developed an experimental style called Forum Theatre. In it, the actors turn the action of a theatre piece about oppression over to the audience. The audience then has complete control over what happens next and can seek different alternatives to oppression. Since his election, Boal has used these alternatives from various Forum Theatre experiences to promote legislation (Heritage 1994). The idea of involving the audience in this way with slight modifications offers museums opportunities to have visitors explore subjects within any discipline from their own perspective. However, it should not be taken on lightly. By getting visitors involved, we have a responsibility to ensure that they are not manipulated or judged in the process. Theatre's power to address issues on such a personal level must be recognized and honored. With this

power come questions about our own ethics and values. How can theatre avoid becoming propaganda? We have an obligation to be honest about our values, providing balanced points of view, and very clear about what we are doing. How do we conduct ourselves in museum theatre, and how do we address subjects colored by ethics and values?

An experience I had as a visitor to a large museum got me thinking about ethics. During this visit, I heard an announcement over the public address system that an event was going to take place in a certain part of an exhibition hall. I was expecting a theatre experience. I entered the area defined by a sign that had the title on it and saw a person leaning on a table before several rows of benches. I assumed this to be the actor. I sat down on a bench with a few people and waited for the actor to begin. This person did begin speaking, but with no acknowledgment that it was actually the beginning of a show. Rather, it began as if we were continuing a previous conversation, picking up where we had left off. The actor nonchalantly told a very personal family story, never moving very much from the table. It had no hallmarks of a theatre presentation, such as lights or movement. As the actor continued, I began to feel disconcerted. Was this really an actor, or was this actually this person's family history? It was an incredible, emotional story, full of drama, unfolding in a matter-of-fact manner from the actor. Visitors were rapt, and when a particularly tragic moment was recounted, tears were rolling down the cheek of one of my companions. Another friend and I remained aloof, skeptical at the proceedings. More than anything, I wanted to know if I was watching theatre or not. The actor finished the story without flourish and said people could come up and talk if they wanted. The actor did not take a bow or indicate that this was part of a museum theatre program. From where I sat, I asked if that was a real story. The actor chuckled and replied that it was not. It was a composite of different stories. It was at this point that the actor declared, "I am an actor." The actor seemed to enjoy the confusion. I felt manipulated. In museum theatre, we have the power to take visitors down some very emotional paths, to experience personal transformative experiences, and I think it is tantamount that we do not try to fool the visitor into doing this. That is misuse of theatre. We have an ethical obligation to make the contract clear to the visitor, to have their full agreement.

Separating what is real and what is theatre can be difficult for visitors. If a play is working well, the audience will have suspended their disbelief and accepted the reality of the play. Children especially seem ready to believe that you are the character you are playing, no matter that you are in a hoop skirt. We have had relationships assumed in the school program of *The Ballad of Chico Mendes*, during which there is a lot of close physical work between the two characters. The students have asked myself and each of the actors I've worked with if we are married.

In some projects at the Museum of Science, we have tried to stretch the boundaries of verisimilitude and have found that visitors will accept the reality of the play for the time of the play, and then be able to return to their own realities. The fact that they are watching actors, who they might have just spoken with before the play began, melts away as the play progresses. In *UFOs Over Massachusetts*, we cast a black actor and a white actress, both around the same age, as father and daughter. The play's style was not strict realism. Both actors played multiple roles and at times talked directly to the audience. This casting worked fine. The issues of the play were the important thing, and this is primarily what visitors talked with the actors about following the play. In *Unsinkable? Unthinkable!* a play about the *Titanic*, the actor plays an albino crab who lives on the wreck of the ship and knows everything about it. The crab is the narrator of the story, but the actor turns into numerous other characters from the *Titanic* during the course of the play. The only physical suggestion of a crab that the audience is given are crab oven mitts, which the actor soon discards, and the actor's introduction as a crab at the beginning of the play. The choice of this character was made by the playwright, Jon Lipsky, inspired by the Omni film *Titanica*, which explored the wreck. The play augmented the film. This choice of character allowed the playwright to give the crab insights into humans and human hubris that a human could never have. Here again, visitors were fully aware that the actor was not a crab, but the story drew them into another reality.

The Museum of Science play *Mapping the Soul* has aspects that concern both areas of ethics and values. To begin with, the two characters in the play are married and the woman is legally blind. Susan Matula, the first actress to play this part, is legally blind. We auditioned only actresses who were visually impaired, who had responded to a notice

126

we put on the hotline for the Massachusetts Coalition for the Blind, four in all. After the play's initial run of a year, she decided to go back to school, and we made the decision to continue with a sighted actor already on staff. We decided that the play was working well, and with Susan's help, we could maintain the integrity of blindness. We were mindful of the ethical implications of doing so. Playing someone who is legally blind is tricky on several levels. The character is only supposed to be able to see blurry figures. We didn't want to play into any stereotypes of a visually impaired person, but we needed to give the audience hints at the beginning of the play without declaring her blindness. Susan had to play up some aspects of blindness, because she was so good at getting around without showing what she was doing.

I am the third actor to play this character, having taken lessons from Susan on how to carry myself. This play is now a high school program, and for the most part, audiences believe I am blind during the show. There are occasional gasps when I take my bow and look out at the audience for the first time, clearly looking around. My acting partner, Richard Hedderman, and I lead a discussion now following the play and I begin by explaining that I am not visually impaired, but the actor who first performed the role was and that she taught me a lot about what it's like to be legally blind. We have had no one protest at our use of a sighted actress, including the occasional audience member from the visually impaired community. I believe this is in part a result of addressing the issue explicitly at the end of the play.

Second, the subjects of *Mapping the Soul* are the ethical and social implications of the Human Genome Project. It was written to be part of the museum's adult-targeted play series, recommended for young adults and older, though children as young as eight have participated in it. It is a participatory play, taking its lead from Boal's Forum Theatre. At two points in the play, the two actors turn to the audience and ask questions, "What would you do? Would you want to know your genetic information?" and "Who would you want to have your genetic information?" The idea is to let the audience explore the issues for themselves. The actors are there to keep the discussion focused, but with any luck, to have little input. As the discussion winds down, the actors return to the script. This improvised section of the play has been everything from volatile and exciting to stilted and abbreviated.

One time a man in his early twenties said he didn't care whether people knew his genetic information and this set off a firestorm of protests from the rest of the audience. They were outraged at his apparent apathy. In this case, the actors had to steer the audience away from judging him, while probing their reasons for not wanting their genetic information distributed. Because the characters represent either side of the argument, the actors can support almost any visitor's input. There is no point of view being espoused by the museum. Another time, following the show, an older man became indignant that the female character, now revealed to be pregnant, would consider having the child and risk passing on the genetic blindness. He felt this to be morally reprehensible. Others in the audience disagreed. I was the actor for this show. After the show, he wanted to know what my personal beliefs were about this, as opposed to the character's. I found this awkward and said so. I was not blind or pregnant in reality, so I felt unable to make a personal judgment.

This line of questioning into actors' personal beliefs has happened quite often when we've dealt with controversial issues. Sometimes the actor and the character will be in sync, and there will be occasions when they are not. Do we have the actor maintain a line of response ordained by the institution? Do we want discussions to degenerate into the personal? Haven't we just asked visitors to do the same? These are questions we all need to think about as we venture into projects of this nature.

Tessa Bridal of the Science Museum of Minnesota (SMM) detailed her museum's experience with a value-laden subject in her article, "Raising the Stakes: The Museum as Forum." Bridal proposes the museum as a place in which to contemplate difficult subjects and theatre as the vehicle with which to carry this out. The SMM has had theatre pieces that examined medical ethics, sex discrimination, aging, racism, and religious bigotry. Its play, *The More the Scarier*, dealt with human population. The process of working on this play began collaboratively as a series of workshops and discussions between a playwright, Dr. Amy Ward, and five actors. Bridal wrote that the goal here "was to establish an atmosphere of trust and honesty as we examined the feelings, assumptions, and biases we brought to the subject of human population" (1994, 39). This mechanism allows for acknowledgment and direct confrontation of the inescapable fact that we all

carry these things into any project, especially those about controversial subjects. By doing so, we might avoid offense and create a deeper, richer theatre piece.

After a long and difficult process of research, specialist speakers, rewrites, previews, and personal commitments by the developing team concerning life choices such as eating meat and having children, the play was put before the visiting public. In an ongoing evaluation effort, visitors are asked to stay after the play and fill out questionnaires. One of the worries in the development phase was that the subject was too hard for people to face and would leave visitors reeling with despair. Asked if they wanted the museum to present more issues of this kind, only one out of more than 100 replies was negative (Bridal 1994, 42).

The Spotted Owl Cafe

The Spotted Owl Cafe project was a challenging experiment for the Science Theatre Program at the Museum of Science. We were setting out to address issues imbedded with values and doing so in the free form of improvisation. It was intimidating, to say the least. The following is an account of the developmental process and experience.

Lesley Kennedy from the Museum of Science was sent to the Science Museum of Minnesota (SMM) to preview the Hunters of the Sky exhibition before its arrival to the Museum of Science. The exhibition focused on birds of prey in North America and issues surrounding different species. She proposed the idea of doing the Spotted Owl Cafe theatre piece to Mike Alexander and me after seeing it there. It was in our minds to go ahead with the project, because we wanted to support any theatrical endeavor connected with a traveling exhibition, if at all possible. We had done so in the past with several plays, including the Science Museum of Minnesota's play with the Bears exhibition.

Lesley described to us the interaction with visitors and the subject of the debate. We also looked at a videotape of the exhibition, which included a few minutes of two actors in the Cafe, speaking with visitors. We received a paragraph describing the Food for Thought concept, as well as newspapers and pamphlets for background information. Eventually, Lesley also supplied us with the book *The Final Forest*, by

William Dietrich. This book became our primary source for research into the Northwest area. Just before the exhibition opened, each of the actors was able to watch the videotape of woodworkers and environmentalists from the Northwest. This provided building blocks for our characters.

I have to admit to finding the Cafe concept difficult to visualize. It is intimidating to think about going into an exhibit and improvising freely with visitors while in character about a very emotional, complex, and controversial issue. Additionally, we did not feel there was enough material to fully understand what was done in the Science Museum of Minnesota. The videotape was technically poor and gave us only a few moments in the Cafe. Additionally, because of the nature of improvisation, very little was written down. Consequently, we did quite a bit of brainstorming among ourselves. Eventually, we got background information on the Cafe space from Don Pohlman of SMM.

Development and Philosophy

As stated already, part of our philosophy in the Science Theater Program is to make whatever we do as clear as possible for the visitors and to allow them the freedom of choice in participating. We are inviting the visitors into a different reality, and if we've made it clear that this will be an enjoyable and interesting experience, rather than difficult or embarrassing, we hope they will agree to take part. We believe we must set the ground rules for the visitors, so that they do not feel the onus is on them to figure them out.

Traditionally, the Science Theater Program has dealt with many controversial and complex topics. In each of these projects, we have striven to present a balanced argument. The actors have endeavored to support visitors' points of view while pursuing the debate within a play. The theoretical goal is to provide the visitors with scientific information that might then inform their lives and their actions, rather than give them a political ideology or make them take a side.

In the Spotted Owl Cafe, we were concerned about avoiding confrontation that might lead to misunderstanding about our role. We decided to use a single actor per day in a role that encompassed various points of view and furthermore to make the characterization as explicit as possible for the visitors.

We were sensitive about playing a modern-day character with no discernible costume. Other museums have experienced problems

when undertaking modern characters on the halls and we wanted to avoid the pitfalls. As an example, in one museum an actor played a reporter, with trench coat and notebook, interviewing visitors in an exhibition related to the media. When visitors realized that the actor had been soliciting their comments under a "false" guise, they felt duped. The museum staff changed this setup immediately, and we had the luxury of benefiting by their experience.

Setup and Structure

We used signage, structured times, announcements, and the Museum of Science's lab coats to avoid confusion. Additionally, each actor set up the improvisation by introducing the Cafe space as "set in Washington state." There were two signs on either side of the entrance to the Cafe:

> Join us in the Spotted Owl Cafe
> Find out about issues of logging Old Growth forests from the
> Cafe's proprietor played by *Museum Performer*
> Ask questions, give opinions, and join the debate
>
> Spotted Owl Cafe
> Performer *IN/OUT*
> Visit the Cafe serving Food for Thought

This information was also on the program schedule that visitors can pick up as they enter the museum. We occasionally found visitors, program in hand, waiting in the Cafe for us to begin. The signs alone did not make the Cafe concept clear to all visitors, but it certainly contributed to many people's understanding. During the action of the improvisation, visitors could be seen referring back to the signs to clarify the event. Many times we could watch as they read them and decided whether or not to come in. As we got more comfortable in the Cafe, we were able to use this time while they read to say hello and invite them into the Cafe or ask whether they had ever heard of the Spotted Owl.

We struggled over how to structure the timing of the "performances." Normally, Science Theater plays are presented on the half-hour, three to four times daily. These plays run an average of twenty to twenty-five minutes. The improvisational nature of the Cafe discussion did not lend itself to such a limited schedule. We wanted to allow more flexibility

with no set ending time, and so we chose to post the beginning times at 10:30, 11:30, and 1:30 weekdays, 11:30, 12:30, and 2:30 weekends, without a definitive ending time. The actor stayed in the Cafe for about 45 minutes each posted time. When the museum was busy, the actor often ended up staying longer than the original 45 minutes. When the actor left the Cafe, he or she switched the in/out sign to alert visitors.

Before most Science Theater plays, an actor announces that the performance is about to begin, inviting visitors in. In the Cafe, we chose to make a similar announcement to all visitors in the Hunters of the Sky exhibition. Wearing a lab coat with the Museum of Science insignia identifying the actor as a museum staff person, the actor announced, "The Spotted Owl Cafe is now open and serving food for thought. If you'd like to come and join me, please do." The actor, not yet in character, would then walk back to the Cafe, move behind the counter, and wait for visitors to enter and sit down. If and when visitors arranged themselves, the actor then announced, with some variation, "Welcome to the Cafe. My name is So-and-so and I work here at the museum, but as I'm speaking to you, I am going to transform into the owner of this Cafe. This Cafe is set in Forks, Washington. When you stepped over that line, you too were transported to Forks." One actor always introduced herself in character first. During this introduction, the actor took off her lab coat and put on a white cook's apron and a Seattle Sonics sports cap. The underlying costume pieces were a flannel shirt, worn jeans, boots, and a down vest. Now in character with costume complete, the actor moved to set up the character's conflict for the audience.

Research and Rehearsal

As mentioned, *The Final Forest* became our primary research source. Each of the four actors, three women and one man, set to play this part were given a copy to use. Though it was dense, we found the book to be exactly what we needed to build a believable and complicated character from the Northwest. Because many of the characters in the book lived in Forks, Washington, we decided to place our character there. We scoured the news for current information relating to the Spotted Owl Controversy. We watched the exhibit video for language and character traits.

How to proceed in rehearsal was somewhat problematic for us, because of the improvisational nature of the project and the subject. We debated amongst us whether to develop a script to work from or keep it looser. We needed to hone in on the focus of our improvisation. We had so much information that it became overwhelming. We wanted to address the complexity of the debate and avoid sound bites. In the end, we agreed to create an outline and a character who would be the owner and sole worker of the Cafe, whose family was asking him/her to take a position in the debate through two petitions. The two petitions were diametrically opposed, one coming from the father and the other from the brother. We wanted to make it as personal as possible, using specific names and personal attributes for each family member, rather than remaining vague.

The actors developed their own outlines. All were similar. The following is mine as an example:

I. Introduce myself and the Cafe: The audience needs to understand the scene.

II. Point out owl paraphernalia and in so doing allude to the controversy:

 a. "I didn't do the decorations myself. I let people come in from the town and they can put up something that's on their mind."

 b. Set up controversy, "It's kind of like this town." "It's not just about the owl—it's much bigger than that."

III. Introduce my family and the petition:

 a. "My family is a lot like this Cafe."

 b. Introduce petition: For/against sale of salvage timber that is part of Congress' budget recissions bill. "What should I do?"

 c. History of the area.

 d. Description of logging.

IV. Talk about the forest:

 a. "You probably don't get a chance to see forests this grand in Massachusetts." "I grew up in these woods." Talk about seeing the spotted owl.

 b. Solicit from audience, ask "What do you like to do when you're in the forest?" which can lead into "What are forests for?"

V. Point out that it's more than about the owl. It's a continuing debate on how we interact with nature and use natural resources. Make the connection between consumer goods and their origins.

Questions to ask, according to the audience
1. What do you think are the big issues?
2. Do you think people should be able to do what they're trained for?
3. Do you think we'll be better off maintaining diversity in the ecosystem?
4. What about science? What does it tell us?

Of course, this was only our beginning. We ventured beyond this structure. Though many pieces remained, they surfaced in different places in the discussion. In fact, as time went on the actors began to accumulate material from visitors. Each day, visitors contributed their opinions and experiences to the mix. When interacting, we could reference something someone said the day before. For example, several visitors talked about how they built a deck or porch with recycled materials. I had no experience with this personally, but if another visitor brought up the subject, I could then relate the previous visitor's experience by saying, "Well, this guy was in the other day and he was telling me . . ." Opinions were worked in as well. We could easily say, "There was a woman in the other day who felt the same as you." Building our improvisations this way made the interactions with visitors natural and very real.

We especially enjoyed the Cafe space as a theatrical set. It gave us a lot to bounce off. The decorations were provocative and telling. Boxes of Spotted Owl Helper produced grimaces and laughter. The paneled walls aroused comments. The windows especially provided us with distinct illustrations for the discussions. Very often, we used the pieces of the Cafe to structure our discussion. We would say, "When my dad comes in, well, he likes to sit where you're sitting, there in the corner. He feels real comfortable over there [next to logger propaganda]." Toward the end, pointing to the Douglas Fir, I always asked the audience, "How old do you think that tree is?" Everyone wanted to guess, and the guesses ranged from twenty years to a million. This led into talking about what defined a rain forest. Each actor stood behind the counter, standing or sitting on a tall stool. The three stools in front of the counter became the "prize seats" for children, though we did have to institute the rule: "Whoever sits there can't spin around."

The Experience

We kept a log of how many visitors came into the Cafe during each 45-minute segment. We did not have the ability to average the length of the visitors' stay. An approximation from our comment log is between ten to fifteen minutes.

Oct = 1440, average of 18
Nov = 1654, average of 19
Dec = 1291, average of 14
Total sessions (each 45 minutes long) = 266
Total audience = 4,385 for 3 months

There was a wide variety of experience in the Cafe, which the numbers do not necessarily capture. The discussions were one to one, or one to fifty. There was the hit-and-run experience, when visitors wanted to know what it is all about but not necessarily contribute. In these cases, our focus was to set the scene of the Cafe and get the differing sides of the debate out. There were larger discussions between mixed groups of people lasting up to a half hour. A few discussions spanned the entire 45-minute session. Visitor reactions to the Cafe ranged from enthusiastically positive to openly hostile. Thankfully, the latter reaction was infrequent.

We pondered the reasons behind the few hostile responses we encountered. Our guess is that visitors very often assume a museum to have a "liberal" viewpoint toward issues in the environment, whether the museum has done anything like that or not, particularly in Boston. This led to an instant defensiveness in a couple of visitors. They were prepared to argue their opposing case.

It might also have to do with how visitors perceived the exhibit. For instance, visitors tended to try to capture the idea of the Cafe by scanning the walls quickly, and very often this led them to see only one side. Some people would see only the pro-logging propaganda and ask why we wanted to cut down trees, while others would grunt "Hrrumph, tree huggers." Their assumptions did not seem based on what they were looking at as much as where they were coming from. Given the opportunity to respond to these assumptions, we could point out the other side. However, very often these visitors were not

135

interested in listening. It became our policy to let these few visitors have their say, but not to pursue the discussion if they resisted. Let me reiterate that this was a rare occurrence.

We worked very hard to get people to ask questions and contribute to the discussion. We did not have the answers to every questions, because our character wouldn't necessarily have them and to get away from the illusion that anyone working for the Museum of Science is an expert. We found the form of the improvisation flexible, allowing us the freedom to stay out of character when it seemed more appropriate. Occasionally, visitors would ask questions impossible to address in character and we followed their lead, dropping character momentarily or completely.

We began the actor's logbook to gauge our progress and to note problems and solutions. It became a therapeutic chronicle of our triumphs, frustrations, and visitor interaction. One actor did less writing than the other three, but in the end, we have more than twenty-five typewritten pages. Here are a few randomly selected, unedited entries from the different actors.

10/31

10:30 Another school group wandered in—followed by their chaperone. (14-year-old-boys) The boys were pro owl but the chaperone was adamantly pro jobs. He wanted the boys to vote, "Owls vs. people." I stopped him and had them vote on which petition to sign instead. He/they provided a lively debate. Fun to see kids and adults on different sides. One of the boys observed that it was "a short-term solution to a long-term problem."

11:30 (3) Yes, I'm getting lots of concern and questions about sending wood to Japan—also lots of attitude about the industry downsizing anyway—so the loggers need to relocate.

Very slow shift. Three people for a very short time. They are from Switzerland and were not fluent in English so the discussion stayed basic. They seemed excited about the cafe because "Europe has the same problems. We are learning to be more prudent now." Family (4) from Ireland arrived and talked about peat bogs! (Shades of Bog Man's Daughter) Very international day!

2:30 (2/2/4) Young couple—had good-natured chat—he ended up saying, "it's a difficult issue," when he began with, "How can we cut an 800 year old tree?" Agreed that we must live off the land and question is HOW?

Man who said if the owl can't adapt too bad—that's it—been happening since time began.

11/9

10:30 (80) Had 15-20 unfathomably energetic 7th graders from Falmouth, ME. Strong pro-logging—couldn't get most kids to care about the owl. Another group from Falmouth pro-environment. Both groups very talkative and difficult to reign in, but I think some information got across. Groups from Salem, MA; Atkinson, NH; Hingham, MA. Hardly any time to write.

11:30 - 12:30 (22) Four from CT and kids were too young (I guess) and they left quickly after I asked them a question. One man stayed to share thoughts. He related situation to Arizona where astronomers were not allowed to put in telescopes because it would require road through forest. People told me of old growth that's been discovered in Mass. and CT. Four from Brookline, ten from Salem. Saw Simpsons episode where senator accepts bribe to approve sale of timber and related it to this issue (I saw that episode too!). Three from Grafton, had been to Yosemite.

1:30 - 2:30 (15) Two from Keene, one from Spokane, WA, and one from Queens, NY—whose dad owns land that is now National Park and the rules keep changing as to how he can use his land. One man from ME, and one woman from Utah. 2 from Keene. Four and four from Matapoisett.

12/2

Went into character with two boys, their mom and another woman—they all wanted to save the trees, though the boys had no idea why. It seems to me that the first impulse in kids is always to "save" which I find interesting. When do we change that impulse? I asked the boys if they would be willing to pay more for wood? (yes. Live in a smaller house?

(no. Most of the small crowd in the exhibition so far are walking slow-ly by—looking at sign, might say hi when I do, and then move on.

12:30 Getting dull stares to my announcement today. Crowds are reti-cent, unlike last and most Saturdays, some days you got it, some days you don't!

2:30 Man answered question of "what to do" with alternative materials. He seemed to feel that was the end of the discussion. Somewhat unsat-isfying to me. Girls run in and stop to ask what this is all about. I don't mind the quick hit like that—at least they get a bit of the idea. Finally, long conversation with mixed group of adults. Man from WA state "We must look long-term."

It was interesting to note the language and concepts visitors brought into the discussions. We were often surprised at the twisting and turn-ing of the conversations because of their input. Here are some subjects discussed:

overpopulation
Japanese exports
wood industry in New England
their life stories and experiences, i.e., building an addition to their house, building their decks with recycled plastic, visitors brought their own agendas, which surprised us (one of the successes we felt was that we had created something in the museum that allowed a forum for vis-itors' experience to be shared—they became important)
carpenters and woodworkers contributed with their knowledge
out-of-work or downsized workers
religious beliefs
Non-Americans contributed their perspectives

In Conclusion
It has been an exciting experiment, sometimes frightening and some-times sublime. It seems to me that what we have done with the Cafe is provide visitors with a truly explicit value-laden interaction and have asked them to articulate their own values as they concern the environment and their view of science.

Epilogue

The potential for museum theatre is enormous at this time. As the museum world continues to grapple with issues of access, identity, and education, museum theatre is there, waiting to lend a helping hand. It remains an untapped resource for most institutions, and yet there exists few that would not benefit and for which it would not be appropriate.

In order to fulfill this potential, museum theatre practitioners must strive for integrity, both in theatre and museum practices. Museum theatre must walk a fine line between the Disney idea of "edutainment" and those who would separate the two completely. Education and entertainment are not mutually exclusive, and museum theatre can bring the two together in new ways that are having a positive impact on visitors. We must continue to develop theatre programs that are truly interactive and visitor-driven. Museum theatre should be used to look critically at exhibitions, collections, and the ways in which each discipline conducts itself, as well as providing a mechanism for celebration.

As the museum theatre field grows, criticism of it may as well. In fact, when engaging the full power of theatre, it should spark healthy debate. The aspect that should not be up for debate is quality. It is imperative to produce well-acted, well-written, well-researched, and well-supported museum theatre. A lone actor in period costume with no structure or support from an institution will appear foolish. A simplistic, badly written play will not keep anyone's attention. Bad or overzealous acting will ruin more than just one experience.

Grounded in the history of museums and theatre, supported by current educational theory and practice, imbued with the power of narrative, museum theatre is a phoenix rising in the new millenium for museums. Just as Cicero's ideal for theatre was to hold a mirror up to nature, so museum theatre's is to hold the mirror up to the face of museums.

Appendix 1

Resource Organizations

INTERNATIONAL MUSEUM THEATRE ALLIANCE (IMTAL)
Museum of Science
Science Park
Boston, MA 02114
617-589-0449 fax-0454
imtal@mos.org
website: www.mos.org/IMTAL/

It's a professional resource!
The International Museum Theatre Alliance, formed in 1990, is a professional resource and networking organization for museum and theatre professionals using theatre as an interpretive technique. The Alliance is open to all styles and techniques of this expanding medium.

It's a communication network!
In 1994, IMTAL became the Affiliate Group on Museum Theatre for the American Association of Museums. Through this relationship, and with associate members such as Heritage Interpretation International, IMTAL exchanges and disseminates information. The Alliance serves as a forum for developments, debate and opportunities in museum theatre.

It's for everyone!
IMTAL is composed of an international membership of science, natural history, art, architecture, applied arts and science, history, and children's museums; zoos and aquariums; and playwrights, directors and performers.

IMTAL is overseen by an Executive Director and nine member multi-national board of directors, representing a full spectrum of museums.

Publications
- Discount on *Perspectives on MuseumTheatre*, a resource report of evaluations and articles, developed with the American Association of Museums.
- Subscription to *IMTAL INSIGHTS*, a quarterly newsletter containing articles by museum and theatre professionals.
- Annual Membership Directory, detailing IMTAL members' programs and productions.

Valuable Information
- Letter and telephone referrals for museums and artists.
- Support for start-up programs.
- Access to proven scripts and theatre program structures.

Opportunities to Come Together
- Annual meeting during AAM's Annual Conference.
- IMTAL has presented sessions at over 30 regional, national, and international conferences.
- Future seminars and workshops on subjects related to museum theatre such as evaluation.
- Script exchanges and touring productions

To JOIN, call the IMTAL office at 617-589-0449.

Other Related Organizations
American Alliance for Theatre and Education (AATE)
Department of Theatre
Arizona State University, Box 872002
Tempe, AZ 85287 USA
602-965-6064
http://www.aate.com

American Association for State and Local History (AASLH)
530 Church Street Suite 600
Nashville, TN 37219-2325
615-255-2971 fax-2979
http://www.aaslh.org

Association for Living Historical Farms and Agricultural Museums
(ALHFAM)
http://www.mystic.org/alhfam

Museum Theatre Professional Interest Council
Science Museum of Minnesota
30 East 10th Street
St. Paul, MN 55101 USA
612-221-4560

National Storytelling Association
P.O. Box 309
Jonesborough, TN 37659
615-753-2171 or 800-525-4514
fax 615-753-9331
http://members.aol.com/storypage/nsa.htm#background

National Association for Interpretation
Cultural Interpretation and Living History Group
Executive Director email <naiexecdir@aol.com>
888-900-8283
http://www.interpnet.com

Appendix 2

The Scientific Storyteller School Program

Catherine Hughes/Robin Mello
Museum of Science, Boston

Welcome teachers. The show that we've developed for your classes contains scientific information and imaginative stories that deal with questions about the natural world. The following packet of information is provided to you as a resource. We also hope you will explore the exhibits listed after the show. If you have further questions, please feel free to contact the Science Theater Program at 617-589-0449. Enjoy the show.

List of Exhibits in Museum of Science Related to Stories

Permanent
- Rain Forest Gallery, 2nd floor, Blue Wing
 - Fruit Bat
 - Sloth
- Buffalo Diorama, Basement, Green Wing
- Ichthyosaur, Stairwell between 1st and 2nd floor, Green Wing
- Dinosaur Gallery, Basement, Blue Wing
- Human Biology & Evolution Gallery, Basement, Green Wing
- Library, 3rd Floor, Green Wing

Temporary
- Bats Exhibition, 2nd Floor, Red and Green Wing
 Ending January 1, 1997

Definition of Terms

Science is defined in this show as a way of observing and understanding ourselves and the world around us. Science derives facts from theories, asks questions and develops hypotheses, designs experiments and finally, analyzes results.

A **Story** is a narrative that contains a plot structure. People often talk in story forms and a great deal of conversation, memory, complaints, and information is told as a story. Stories come in many forms. A few of these are plays, film, television, computer games, songs, books, and poems. Traditional stories, or oral literature, were collected by folklorists and have been handed down from generation to generation. In our Scientific Storyteller show we present a wide variety of oral literature:

Myth: A myth is an oral literature that describes a world larger than life. Myths are heroic and epic and often tell (in imaginary terms) about how the natural world was created.

Legends: Legends are stories that are attached to a place or region. A tall tale is a kind of legend that exaggerates these facts.

Folk-tales: In most cultures folk-tales, or fairy tales, are told as entertainment. These stories contain imaginary creatures, magical occurrences, and often a great deal of humor.

In our show we also use informational stories. For example:
Memory: Memories and life stories are actual events that people retell about themselves and/or their families. Memories are the foundation for autobiography and personal history.

Biography: A biography is the life story of a person. In our show we use biographical information to dramatize an event in the life of Mary Anning.

In addition, we also dramatize/tell facts and information such as "the story of" early efforts to excavate fossil remains in ancient China or the life of the Three-Toed Sloth.

Why Should Stories Be Told in the Classroom Environment?

- Telling stories out loud enhances listening, communication, and language acquisition.
- Storytelling uses creative intelligences and incorporates different learning styles, so that stories encourage students to explore and understand information in a variety of ways.
- Stories come from all cultures, and by including stories from different cultures, students can be exposed to alternative views.
- Stories have been found to help children understand complex theories by making those theories personal.
- Studies have found that facts are best remembered if imbedded in a narrative, so that talking about science in story form allows students to structure, remember and access that information more easily.

Suggested Activity

Biography Alive!
In this show, we present moments from the life of Mary Anning, one of the youngest and earliest paleontologists from the 19th century. Here is an activity that can help your students to discover the work and lives of other unsung scientists.

We suggest you check out alternative resources, as well as your library, for biographical information on the lives of scientists. We encourage you to use your local historical society or archives for information on scientists that you might not know about from your own backyard.

Setup: Ask students to choose one scientist from the research. The children can cross genders, race, age to pick their scientist. This can be done cooperatively or solo.

Have students collect facts about their scientist's lives and work, along with excerpts from speeches, diaries, or notes.

Then have them act out the part of their scientist for the rest of the class. This can also be done in an interview format, with the other students asking questions and taking notes. Have fun!

145

Bibliography

Cole, S. 1991. *The Dragon in the Cliff: A Novel Based on the Life of Mary Anning.* New York: Lothrop, Lee & Shepard. A biography, written for young adults, that describes the life work of Mary Anning, an eleven-year-old girl, who became one of the world's first paleontologists, though rarely acknowledged in her lifetime.

Day, David. 1981. *The Doomsday Book of Animals: A Natural History of Vanished Species.* New York: Viking Press. An annotated listing of extinct and endangered animals. Song "We're All One Circle" comes from this.

Elder, J., and H. D. Wong. 1994. *Family of Earth and Sky: Indigenous Tales from Around the World.* Boston: Beacon Press. A well-researched anthology of animal tales from world cultures including many pourquoi (why) tales.

Goodman, Susan. 1995. *Bats, Bugs and Biodiversity: Adventures in the Amazonian Rain Forest.* New York: Atheneum Books.

Krupp, E. C. 1991. *Beyond the Blue Horizon: Myths and Legends of the Sun, Moon, Stars, and Planets.* New York: Oxford University Press. A wonderful book that makes connections between story and scientific information about astronomy and earth science. A great resource for both scientists and storytellers.

Leaf, M. 1987. *Eyes of the Dragon.* New York: Lothrop, Lee & Shepard. A Chinese folktale about a dragon that comes to life.

Leakey, R. 1994. *The Origin of Humankind.* New York: Basic Books. A readable up-to-date account of "the origin of the species," including discussions regarding scientific debates and controversies surrounding the subject of human evolution.

Martin, K., and E. Miller. 1988. "Storytelling and Science." *Language Arts* 65 (3): 255–59. Experienced teachers discuss how they connect storytelling and science learning in their elementary and middle school classrooms.

McGowen, C. 1991. *Dinosaurs, Spitfires, and Sea Dragons.* Cambridge, MA: Harvard University Press. Absolutely everything you ever wanted to know about ichthyosaurs, including theories about how they might have evolved, developed, and lived in ancient water environments. This book also includes an entire chapter on Mary Anning, early paleontology and the area of Lyme Regis, England, where the first plesiosaurs and ichthyosaurs were discovered.

National Wildlife Federation. 1989. *Rain Forests: Tropical Treasures*. This is one of the Ranger Rick Nature Scopes with lots of ideas for teachers.

Paley, V. G. 1990. *The Boy Who Would Be a Helicopter: The Uses of Storytelling in the Classroom*. Cambridge, MA: Harvard University Press. Paley describes her "storytelling classroom" and uses anecdotes from her teaching experience to illustrate the need for and uses of story in learning environments.

Patent, Dorothy Hinshaw. 1986. *Buffalo: The American Bison Today*. Clarion Books.

Pittman, H. C. 1986. *A Grain of Rice*. New York: Hastings House. A Chinese folktale that solves a mathematical problem.

Prelutsky, J. 1993. *The Dragons Are Singing Tonight*. New York: Greenwillow. Children's poet Jack Prelutsky presents the humorous side of dragon lore with seventeen poems, each about dragons.

Ragache, G. 1991. *Myths and Legends of Dragons*. New York: Cavendish. Children's book that tells stories from western cultures about dragons and other mythical monsters.

Sagan, C. 1977. *The Dragons of Eden: Speculations of the Evolution of Human Intelligence*. New York: Random House. Seminal work discussing the theories behind the development of human consciousness and how we make meaning from our world.

Shannon, G. 1994. *Still More Stories to Solve: Fourteen Folktales from Around the World*. New York: Greenwillow. A collection of science and math stories taken from traditional sources from world cultures. This book is the sequel to *Stories to Solve* and *More Stories to Solve*.

Shenkle, A. M. 1994. "Connecting Science and Language Arts." *Learning* (April/May): 68–70. Article discussing the connections between science and literacy learning.

Stanley, S. 1987. *Extinction*. New York: Scientific American Books. An indepth discussion regarding the theories, types, and development of extinctions. The author discusses how extinction fits into the processes of evolution bringing it current with modern times.

Tuttle, Melvin. 1991. *Batman: Exploring the World of Bats*. New York: Scribner's. Everything you ever wanted to know about bats, and more.

Bibliography

Adolphe, Soukiana, Lynn Baum, and Catherine Hughes. 1997. Preliminary report on *The Masque of Leonardo*. Museum of Science, Boston.

Alexander, Edward P. 1979. *Museums in Motion: An Introduction to the History and Functions of Museums.* Nashville, TN: American Association for State and Local History.

Alexander, Michael. 1994. Personal interview, 25 February.

Alsford, Stephen, and David Parry. 1991. "Interpretive Theatre: A Role in Museums." *Museum Management and Curatorship* 10: 8–23.

American Association of Museums. 1996. American Association of Museums Annual conference, Minneapolis, Minnesota.

———. 1984. Museums for a New Century report. Washington, DC: American Association of Museums.

American Heritage Dictionary of the English Language. 1992. 3d ed. Boston: Houghton Mifflin.

Anderson, Jay. 1984. *Time Machines.* Nashville, TN: American Association for State and Local History.

Barranger, M. S. 1986. *Theatre: A Way of Seeing.* Belmont, CA: Wadsworth.

Baum, Lynn. 1991a. Unpublished evaluation of *Stuck in Time* (1989), Museum of Science, Boston.

———. 1991b. Unpublished evaluation of *The Ballad of Chico Mendes* (1990), Museum of Science, Boston.

Bedworth, Jacalyn, and Sondra Quinn. 1993. "Science Theatre: An Affective Interpretive Technique in Museums." *Perspectives on Museum Theatre Forum:* 7–14.

Berry, Nancy, and Susan Meyer, ed. 1989. *Museum Education: History, Theory and Practice.* Reston, VA: The National Art Education Association.

Bicknell, Sandra, and Xerxes Mazda. 1993. "Enlightening or Embarrassing: An Evaluation of Drama in the Science Museum." London: National Museum of Science and Industry.

Bishop, Conrad, and Elizabeth Fuller. 1993. A Friend from High School. Unpublished playscript, commissioned by Franklin Institute, Philadelphia, PA.

Blais, Jean-Marc, ed. 1997. *The Languages of Live Interpretation*. Hull, QC: Canadian Museum of Civilization.

Brecht, B. 1964. *Brecht on Theatre*. New York: Hill and Wang.

Bridal, T. 1994. "Raising the Stakes: The Museum as Forum." *Sourcebook*. Washington, DC: American Association of Museums.

Brockett, Oscar G. 1982. *History of the Theatre*. 4th ed. Boston: Allyn and Bacon.

Brown, Nancy Marie. 1993. "Singular Women." *Research/Penn State* (March): 16–21.

Bruner, J. 1986. *Actual Minds, Possible Worlds*. Cambridge, MA: Harvard University Press.

———. 1965. *On Knowing: Essays from the Left Hand*. New York: Atheneum.

Courtney, Richard. 1974. *Play, Drama, and Thought*. New York: Drama Book Specialists.

Csikszentmihalyi, M., and Kim Hermanson. 1995. "What Makes Visitors Want to Learn." *Museum News* 74 (3): 34–37, 59–62.

Cuomo, S., and George Hein. 1994. Mysteries of the Bog Evaluation Report. Cambridge: Lesley College Program Evaluation and Research Group.

Davison, V., et al. 1993. Animals as Actors: Take 2. Unpublished evaluation. Zoo Atlanta.

Dewey, J. 1938. *Experience and Education*. New York and London: Collier MacMillan Publishers.

Dezell, Maureen. 1993. "Different Strokes." *The Boston Phoenix*, 13 August, 24–25.

Filisky, Michael. 1989. "Science on Stage: The Uses of Theatre in Science Museums." Cambridge, MA: Educational Services.

Finton, Robert. 1997. Conversation with the author.

———. 1992. "IMTAL Members Present in St. Paul." *IMTAL INSIGHTS* November (3).

Gardner, Howard. 1993. *Frames of Minds: The Theory of Multiple Intelligences*. 2d ed. New York: Basic Books.

———. 1991. *The Unschooled Mind*. New York: Basic Books.

Gonzales, Jo Beth. 1993. The Dramatic Intelligence and Gardner's Theory of Mulitple Intelligences: Connecting Creative Drama to Science Pedagogy. Unpublished paper, Bowling Green State University.

Grinell, Sheila. 1979. A Stage for Science. Report. Washington, DC: Association for Science-Technology Centers.

Hartigan, Patti. 1993. "JFK Library in Danger of Dropping the Torch." *The Boston Globe*, 3 November, city edition.

Hein, George E. 1997a. *Learning in the Museum*. London: Routledge.

———. 1997b. "The Maze and the Web: Implications of Constructivist Theory for Visitor Studies." Visitors Studies Association Keynote Speech.

_____. 1995. "The Constructivist Museum." *Journal of Education in Museums* 16: 15–17.

Hein, George E., Pamela Lagarde, and Sabra Price. 1986. "Mary Rose Exhibit at the Museum of Science." Final evaluation report. Cambridge, MA: Program Evaluation and Research Group.

Heritage, P. 1994. "The Courage to Be Happy: Augusto Boal, Legislative Theatre, and the 7th International Festival of the Theatre of the Oppressed; Brazilian Politician and Theatre Advocate." *Drama Review*. New York University and Massachusetts Institute of Technology.

Hilton, Julian, ed. 1993. *New Directions in Theatre*. New York: St. Martin's Press.

Hirzy, Ellen Cochran, ed. 1992. *Excellence and Equity: Education and the Public Dimension of Museums*. Washington, DC: American Association of Museums.

Hooper-Greenhill, Eilean. 1992. *Museums and the Shaping of Knowledge*. London: Routledge.

Hughes, Catherine. 1993. Master's thesis, Lesley College, Cambridge, MA.

Jones, D. Reprinted 1993. "Uniting Audiences, Theater, and Interpretation: The Time Is Right." *Perspectives on Museum Theatre*.

Karp, Ivan, and Steven D. Lavine, eds. 1991. *Exhibiting Cultures*. Washington, DC: Smithsonian Institution Press.

Landy, Robert J. 1982. *Handbook of Educational Drama and Theatre*. Westport, CT: Greenwood Press.

Lipsky, Jon. 1994. Personal interview, 6 March.

Matthews, C. 1996. Still on the Journey. Unpublished thesis, Hampton University.

McCaslin, Nellie. 1984. *Creative Drama in the Classroom.* 4th ed. New York: Longman.

McConnell, Maureen. 1994. Personal interview, 28 February.

Mello, Robin. 1994. "Who Has Cultural Ownership of Stories?" *The Lanes Museletter* 7 (2): 4–6.

Miller, D. Stuart. 1991. "Expectations for Interpretive Theatre: Using Prior Research as a Guide." *IMTAL INSIGHTS* (August): 1–3.

———. 1988. The Effect of Interpretive Theatre on Children in the Museum Setting. Thesis, Georgia Southern College.

Mitchell-Innes, F. 1997. "Dance Among the Dinosaurs." *INSIGHTS* 8/1. Boston: International Museum Theatre Alliance.

Moore, Juanita. 1993. Speech. American Association of Museums annual meeting, Fort Worth, TX.

Munley, Mary Ellen. Reprinted 1993. "Buyin' Freedom." *Perspectives on Museum Theatre:* 69–94.

O'Connell, Peter. 1993. "Museum Education Programs in the Nineties: Challenges and Changes." *NEMA News* (3 March).

Parry, David. 1994. Personal interview, 3 March.

Patton, Michael Quinn. 1990. *Qualitative Evaluation and Research Methods,* 2d ed. Newbury Park, CA: Sage Publications.

Roberts, L. C. 1997. *From Knowledge to Narrative: Educators and the Changing Museum.* Washington, DC: Smithsonian Institution Press.

Rubenstein, Rosalyn, Harry Needham, and Associates. 1993. "Evaluation of the Live Interpretation Program at the Canadian Museum of Civilization." *Perspectives on Museum Theatre Forum:* 95–142.

Rutowski, P. Reprinted 1993. "Theater Techniques in an Aquarium or a Natural History Museum." *Perspectives on Museum Theatre:* 19–22.

Serino, Justine. 1994. Personal interview.

Serrell, B. 1997. "Paying Attention: The Duration and Allocation of Visitors' Time in Museum Exhibitions." *Curator* 40 (2): 108.

Schindel, Dorothy Napp, and Jennifer Fells Hayes. 1994. *Pioneer Journeys: Drama in Museum Education.* Charlottesville, VA: New Plays Books.

Serino, Justine. 1994. Personal interview.

Shane, John. 1994. Personal interview, 16 March.

Shevtsova, M. 1993. *Theatre and Cultural Interaction.* Sydney: University of Sydney.

Sternberg, S. Reprinted 1993. "The Art of Participation." *Perspectives on Museum Theatre*, 35–46.

Stillman, Diane Brandt. 1992. "Art From Art: Paintings and Sculptures Thicken the Plot." *Sourcebook*. Washington, DC: American Association of Museums.

Strand, John. 1993. "The Storyteller." *Museum News* (March/April): 40–43, 51.

Strauss, Susan. 1996. *The Passionate Fact: Storytelling in Natural History and Cultural Interpretation*. Golden, CO: North American Press.

Tchen, John Kuo Wei. 1993. Speech. American Association of Museums annual meeting. Fort Worth, TX.

Tilden, F. 1957. *Interpreting Our Heritage*. Chapel Hill: University of North Carolina Press.

Toole, Betty Alexandra. 1992. *Ada, The Enchantress of Numbers: A Selection from the Letters of Lord Byron's Daughter and Her Description of the First Computer*. Mill Valley, CA: Strawberry Press.

Trudel, J. 1989. "The First Generation of Exhibitions at the Musee de la Civilisation." *Muse* 7 (2): 68–71.

Way, Brian. 1967. *Development Through Drama*. Atlantic Highlands, NJ: Humanities Press.

Weil, Stephen. 1990. *Rethinking the Museum and Other Meditations*. Washington and London: Smithsonian Institution Press.

Wickham, Glynne. 1992. *A History of Theatre*. 2d ed. New York: Cambridge University Press.